INNOVATIVE TECHNIQUES FOR
WEDDING PHOTOGRAPHY

David Neil Arndt

AMHERST MEDIA, INC. ■ BUFFALO, NY

GC

Photographs by: David Arndt; Suzanne Arndt; Carol Andrews; Ricardo de Vengoechea; David Jones; Nikky Lawell; Scott Livermore; Phil Morgan; Fran Reisner; John Unrue; Janice Wheatley; Ken Wheatley.

Published by:
Amherst Media, Inc.
P.O. Box 586
Buffalo, N.Y. 14226
Fax: 716-874-4508
www.AmherstMediaInc.com

Publisher: Craig Alesse
Senior Editor/Project Manager: Michelle Perkins
Assistant Editor: Matthew A. Kreib

ISBN: 1-58428-025-5
Library of Congress Card Catalog Number: 99-76593

Printed in the United States of America.
10 9 8 7 6 5 4 3 2 1

TABLE OF CONTENTS

Section One
THE AESTHETICS OF OLD & NEW

Chapter 1

Chapter 2

Section Two
Organization and Equipment

Section Three
Achieving the New Styles

	Section Four
	The Business of Wedding Photography

PREFACE

The wedding photography industry is changing.

A new generation of couples are marrying at the rate of 2,800,000 weddings each year according to a 1998 study done by the Photo Marketing Association. American couples spend about $3,500,000,000 ($3.5 billion) on their special events. That is an average of $12,500 per wedding.

Until recently, these 2.8 million couples had little influence over how their weddings were photographed. The wedding photography industry had adopted a formal, rigid style based on studio portraiture. Judging by the standards of photographers using the new styles detailed in this book, portraiture-based wedding photography places excessive emphasis on detailed posing. Details such as placement of the hand on the hip, location of the bridal veil and the position of the wedding gown train on the floor were checked before each picture was taken. Every set-up could take several minutes to fix. Brides and grooms were adjusted as if they were clothing store mannequins. Wedding photographers, comfortable with the tight control over lighting and posing that is possible in a studio, attempted to maintain that control in the chaotic world outside the studio. They rarely succeeded. Clients usually tolerated this abuse in silence because they were taught (by photographers) that detailed posing was the only way to get good pictures. Sometimes brides would break down in tears because photographers were ruining the magical wedding day that they had dreamed about for years.

Wedding photographers using the new styles are teaching brides, through advertising and in practice, that they don't have to suffer through endless posing on their wedding day. This book details a better way.

"The wedding photography industry is changing."

Amateur photographers should read this book before they photograph a friend's wedding or start a career as a wedding photographer so that they can learn the successful techniques of the accomplished photographers featured in this book. Knowing these techniques will result in superior pictures.

In this book, professional and amateur photographers alike will learn:

- why weddings have been photographed the same way since the end of World War II
- about the revolutionary changes in wedding photography
- how to photograph in photojournalism, documentation, fashion, and fine art styles
- how to capture motion and emotion

- how to control perspective, composition, and depth of field through lens selection
- how to better satisfy the desires of the bride and groom, parents, attendants and guests
- how to increase sales volume and profit margins
- sales presentation points to enhance the effectiveness of each client/ photographer meeting
- about new wedding photography products

Everyone will benefit from seeing portfolio quality photos from twelve of the most creative wedding photographers. These memorable examples can be duplicated and adapted.

The last section of this book includes a list of useful trade associations, websites, and helpful books on wedding photography, various photographic styles and related topics.

"... increase sales volume and profit margins..."

INTRODUCTION

◘ The Hidden Wedding

On the surface, marriages are routine events; thousands happen every Saturday. But in reality, weddings are social and political events filled with interesting activities, compromises, emotions, action and drama. Every participant sees the wedding day from his own perspective. This perspective is based on his knowledge and relationship to the couple and other guests. For example, the author's wedding was planned to accommodate the demands of guests with four different faiths. Without the adjustments many guests would not have attended.

Each new generation looks at life from a new perspective and with different political views. Today's bride and groom grew-up in a culture different from the Baby Boomers or the World War II generation. Today's bride and groom have different expectations, values and aesthetic senses than their parents and grandparents. It's natural that many of them demand their wedding photographs reflect their beliefs and lifestyles.

Changing photographic technology has greatly influenced how weddings are documented. Up until the mid 1950's, weddings were shot in black and white with Crown or Speed Graphic cameras using 4x5 inch sheet film. Indoors, light came from disposable flashbulbs. These cameras were heavy and slow to operate, thereby limiting the way wedding photographers were able to work. A photographer using a Crown Graphic might take thirty seconds or a minute to prepare for the next picture. From the 1950's until the about the mid-1980's, weddings were shot in color on Rolleiflex, Hasselblad and Mamiya cameras that used medium format film. On-camera electronic flash was standard. A shooter with a Mamiya or Rollei twin-lens cam-

"Today's bride and groom have different expectations..."

9

era could take five to ten seconds to prepare for the next picture. A photographer with a Hasselblad needs about five seconds before shooting the next shot. Photographers often posed pictures so that there was time to advance the film, cock the shutter and focus. Just recharging an old electronic flash could take up to ten seconds.

While some adventurous photographers experimented with candid photographs (while using these bulky, slow cameras), a carefully posed, properly exposed, in-focus, well-composed image was the priority of most wedding photographers in this era. Wedding photographers became adept at arranging groups and guiding brides and grooms into standard, attractive poses. Highly skilled photographers created stunning, but stiff, rigid, posed pictures.

The most serious problem caused by posing pictures is that the wedding and reception proceed at a pace set by the photographer. Participants must put aside their desires and schedules to accommodate the needs of the photographer. In formal wedding pictures, the wedding party and the guests are equivalent to actors and actresses. The photographer becomes a movie director who controls every aspect of the shot. Spontaneity at the reception is replaced by planned events that must be pho-

tographed because the photography contract requires the picture.

The demands of today's bride and groom have forced many photographers to abandon these traditional practices, and explore new styles. Fortunately, with faster and lighter photographic equipment, many of the factors which necessitated traditional styles have also evaporated. Consequently, several new styles of bridal portraiture and wedding photography have emerged.

◻ Beyond Traditional Wedding Photography

The new techniques of wedding photography free wedding parties from the need for photographers to control the pace of weddings and receptions. Some of the liberating factors are the technological advancements being made in photographic films and cameras.

The leading film makers, Eastman Kodak and Fujifilm, are engaged in a titanic struggle for dominance of the world film market. Consequently, genuine improvements in film quality are introduced every year. Color accuracy, graininess and emulsion sensitivity are constantly improving. Many of the advancements are marketed to professionals first – months ahead of being introduced into the amateur market.

Modern, professional level 35mm cameras can shoot up to

"... new styles of wedding photography have emerged."

seven frames per second. Some flash and battery combinations can fully recycle in one second. In today's cameras, focus, exposureand film ISO are set automatically – the film even rewinds itself after the last shot. Modern 35mm cameras have the ability to automate every photographic function except choosing what to photograph and when to photograph it.

Freed from the constraints of the old film and camera technology, posing every picture is no longer necessary. This is not to say that these traditional techniques are no longer used; rather, they are modified and used in conjunction with newer approaches to create uniquely modern styles of photography. Today's creative wedding photographer needs to spend less time on finely detailed posing, and concentrate instead on capturing interesting, spontaneous moments. As a result, the wedding party is also more free to enjoy the ceremony, reception, food, music and dancing.

□ Influence of Music Videos

A major influence on today's photographic preferences is the popularity of music videos. Music video producers continually struggle to create new visual images and styles to accompany the music they are trying to sell. Some of the techniques they use include black and white images, false color, blurs, movement, tilted horizons, objects as metaphors, grainy pictures, odd perspectives and creative camera angles. Their attention-getting techniques are being applied to creative photographic specialties and result in exciting new images. Still photography is enjoying a creative revival after a long period of stagnation, and is recapturing some of the market previously lost to wedding videographers.

□ Fragmentation of Wedding Photography

Like the fragmentation of rock and roll music into multiple subcategories, wedding photography has fractured into multiple specialties. The biggest split was the separation of bridal portraiture from wedding/reception photography. For example, Carol Andrews, a nationally prominent photographer working in Houston, prefers to shoot bridal portraits and assigns wedding day photography to her associates. Consequently, this book will examine portraiture separately from wedding day coverage.

"... posing every picture is no longer necessary."

The Aesthetics of Old and New

1

NEW VS. TRADITIONAL STYLES

□ Equipment

Photographers working in the new styles of wedding photography not only photograph different subjects than formal-style practitioners, but they also use different lenses and films to create their fresh looks.

Formal wedding photography is generally shot with medium format cameras using an 80mm normal lens and a 150mm portrait lens (equivalent to 50mm and 85mm, respectively, in the 35mm format). Contemporary wedding photographers also have, however, a wide array of equipment and accessories that enable them to deal creatively with any situation the wedding might entail. Lenses might range from 600mm $f4$ to a 14mm $f2.8$ fisheye lens. High quality auto-focus zoom lenses can speed up picture-taking by eliminating the need to change lenses.

Films range from ISO 64 to ISO 3,200. A photographer might well carry black & white, infrared, color print or color slide film in his camera bag, so as to be prepared for any unexpected opportunity.

Likewise, there are more options in flash units. Some units zoom to match the settings of certain lenses, others have interchangeable heads which affect the way the scene is illuminated.

□ Posing vs. Staging

In some of the creative new styles, posing photos is considered a bad practice. Posing is seen as an admission that the photographer is not skilled enough to capture a fleeting moment on film or imaginative enough to see a good picture when it happens.

Facility with a camera is a matter of practice and training. Unfortunately, too many college photography classes place so much emphasis on achieving exposure perfection that the

"... they also use different lenses and films to create their fresh looks."

13

photographer never learns how to use the camera instinctively. Learning the Zone System of exposure measurement and film processing along with view camera adjustments is useful and interesting, but it does not always produce a photographer capable of capturing a person's spirit on film. Ansel Adams, inventor of the Zone System, is known for landscapes, but his portraiture is widely ignored. One reason is that the Zone System eliminates spontaneity in the picture. Adams and his disciples often bragged about waiting hours for the right light before taking the picture.

Landscape photographers have the luxury of time; people photographers never have enough time.

An exception to the rule against posing is the practice of staging portraits. Staging a picture is a very rough form of posing in which the photographer loosely sets up a scene to photograph. He might move people that are blocking a picture, or hide a distracting background or foreground element. One example might be avoiding a drunk former boyfriend that is determined to ruin the wedding pictures with obscene gestures

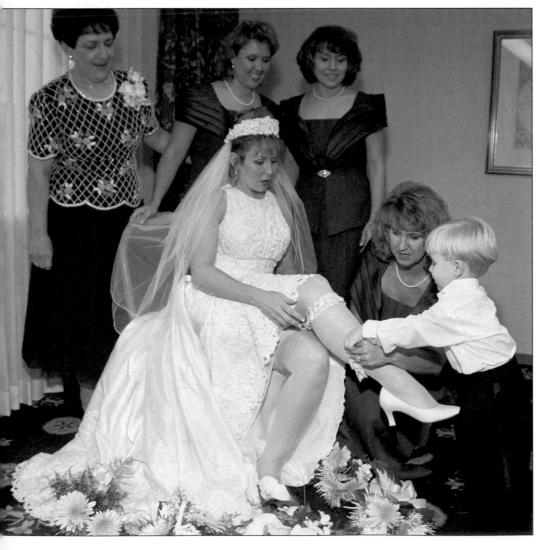

Here, the photographer stages the picture by telling the subjects where to sit and stand or what to do. He did not control hand and leg placement; he just captured their natural expressions, moods and movements. Photo by Ken Wheatley.

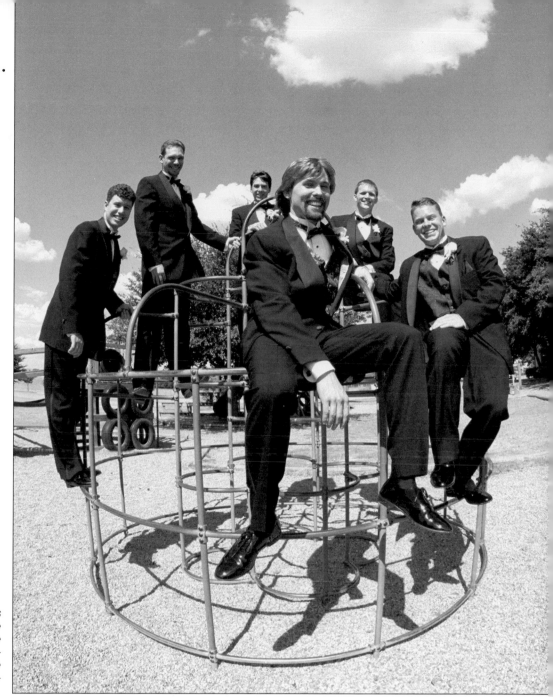

A 14mm lens was used to capture this groom and his groomsmen. The bride suggested this image. Notice how the relative size of each person is exaggerated and the normally straight parts of the play equipment are curved by the fisheye lens. Photo by Ken Wheatley.

while standing in the background of every shot. The photographer might use staging to take advantage of a more interesting background or better natural lighting.

Instead of instructing subjects to tilt their heads just so, or to hold their hands a certain way, the photographer suggests what the subjects could do to create a pleasing image. The subjects are then free to interpret the photographer's guidelines in their own ways. This creates the appearance of a relaxed candid image.

❑ Wide-Angle Lenses

Wide-angle lenses allow the subject to be placed in the foreground so they appear much larger than the objects or people in the background. In this way, more elements can be placed in the picture without distracting from the importance of the main subject. Wide-angle lenses also create various distor-

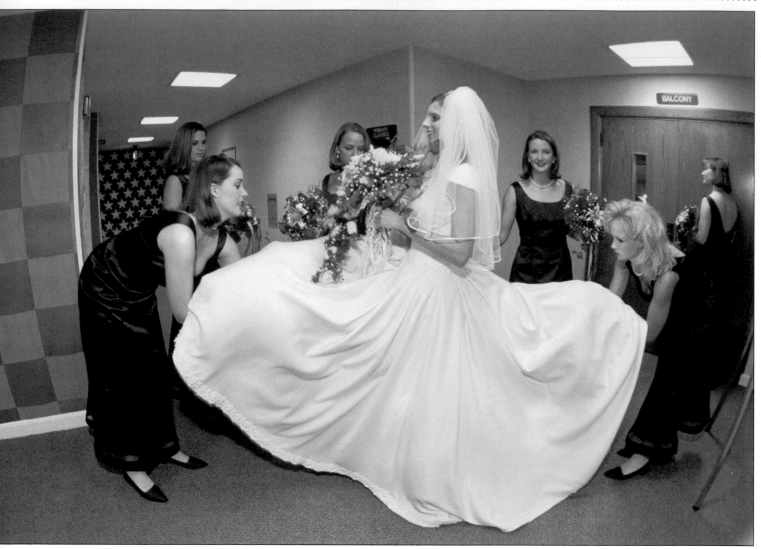

tions, such as the bending of straight lines. This is effective for grabbing attention. The most extreme examples come from 14mm and 15mm fisheye lenses. The distorted perspective and curved lines of a wide-angles lens become key elements in the composition of the picture.

❑ Telephotos

Telephoto lenses are powerful tools in the hands of skillful photographers. They can provide two visual effects to enhance a shots. First, telephotos can focus in on one person in a sea of people. Telephotos

let photographers "intrude" without the subject being aware of the photographer. They can put backgrounds so far out of focus that they disappear (such as at the top of the opposite page). Second, by choosing an appropriate focal length and aperture, telephotos can compress an image (such as at the bottom of the opposite page) so the viewer can see the reaction of people in the background.

Super-telephoto lenses, such as 300mm, 400mm and 500mm, are rarely used indoors by wedding photographers because of

This picture of the bride being prepared for the ceremony does not look distorted until the background is studied. The halls shown are at right angles to each other. The photographer used the characteristics of a fish eye lens to enhance a wonderful picture. This image was made with a 14mm lens in a crowded hall. Photo by Janice Wheatley.

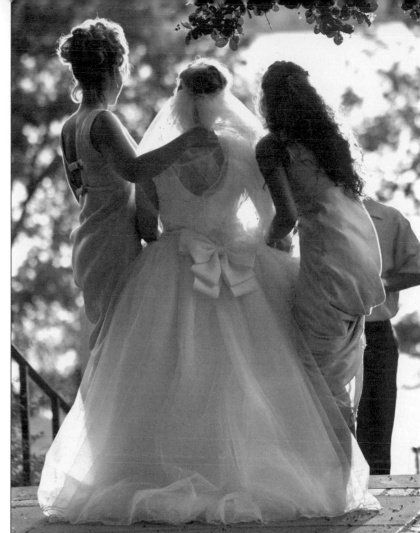

Right: This picture is an example of the control over the background a telephoto, such as a 300mm, gives the photographer. This same scene would show too much background if it was shot with a 50mm, 35mm or 28mm lens. Photo by Janice Wheatley.

Below: "I do" says the bride. The expression on her lips shows clearly. This picture was taken with a zoom lens set to 200mm. Photo by Ken Wheatley.

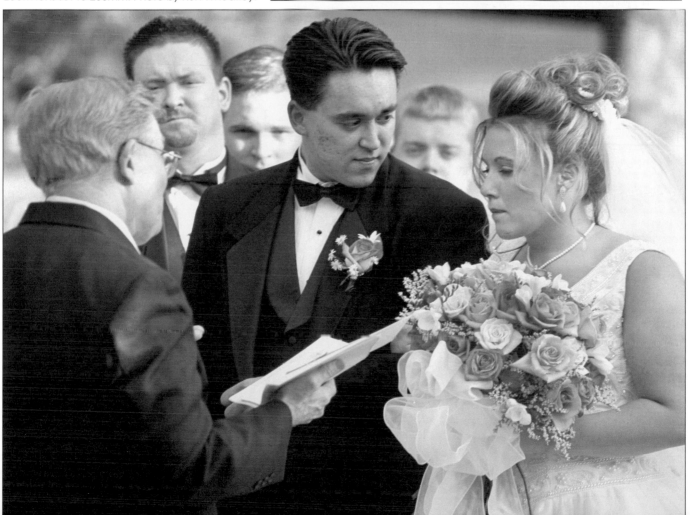

dim lighting in most churches. However, when used with a tripod, a slow shutter speed allows proper exposure. Telephoto lenses on a tripod from the back of the church (or one of the front corners) are viable ways to avoid the clergy's injunction against flash photography during the ceremony. In today's market, many couples consider the yellow cast given by tungsten light bulbs a cutting edge creative technique.

Lots of photographers believe that getting close-up pictures with normal and wide angle lenses is too aggressive and impolite. The telephoto lens is the ideal solution for these concerns. Close-up pictures can be achieved without being close.

◻ Informal Groups

In the formalist wedding photography tradition, group photos are posed in one to five rows, depending on the number of people that must be squeezed into each shot. The goal is to have every face clearly pictured, all the same size and all facing the camera. New styles of wedding photography abandon that concept and favor

Six people are pictured in this informal group, yet it is alive and vibrant because most of the people are busy looking at activities beyond camera range. Their faces are expressive and active. Photo by John Unrue.

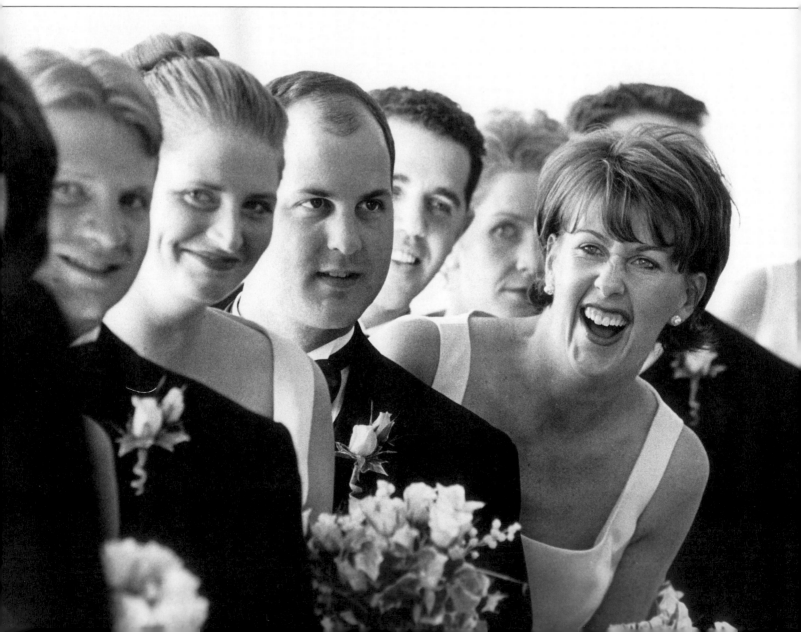

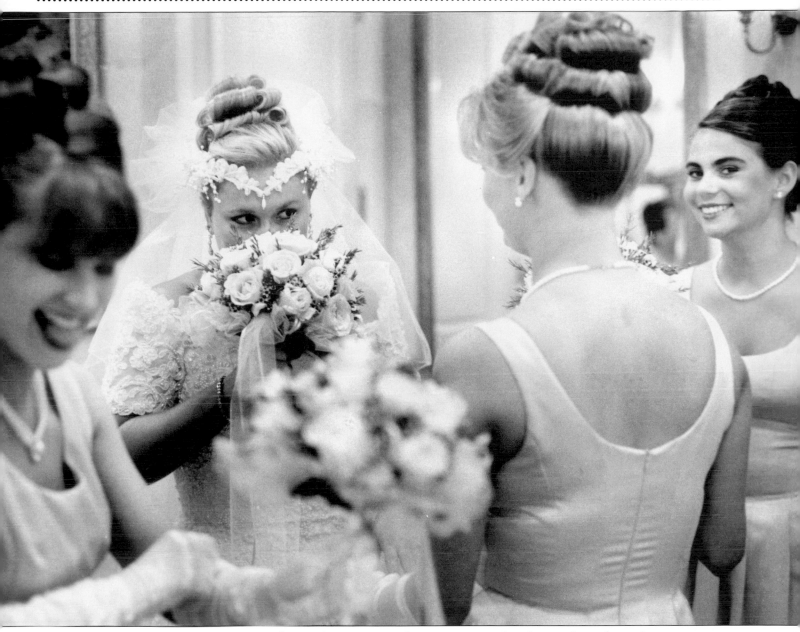

The photographer could have posed the bride and her attendants, but instead chose this active image which he shot with a 85mm lens without a flash. Photo by John Unrue.

informal, unposed groups. Painters rarely place large groups of people in straight line rows. Photographers don't need to do so either. Even *The Last Supper* shows some apostles standing and some seated. They are shown talking in groups. Not all of them face the viewer.

□ Unusual Angles

In the quest for unique, memorable pictures, wedding photographers are turning to

the bag of tricks other genres of the visual arts have used for many years. Today what formalists once considered "errors" are being shot deliberately. Unusual camera angles don't require any special equipment and can be quite easily employed by any clever photographer.

□ Tilting Horizons

Tilted horizons were once the exclusive province of the 1960's *Batman* television

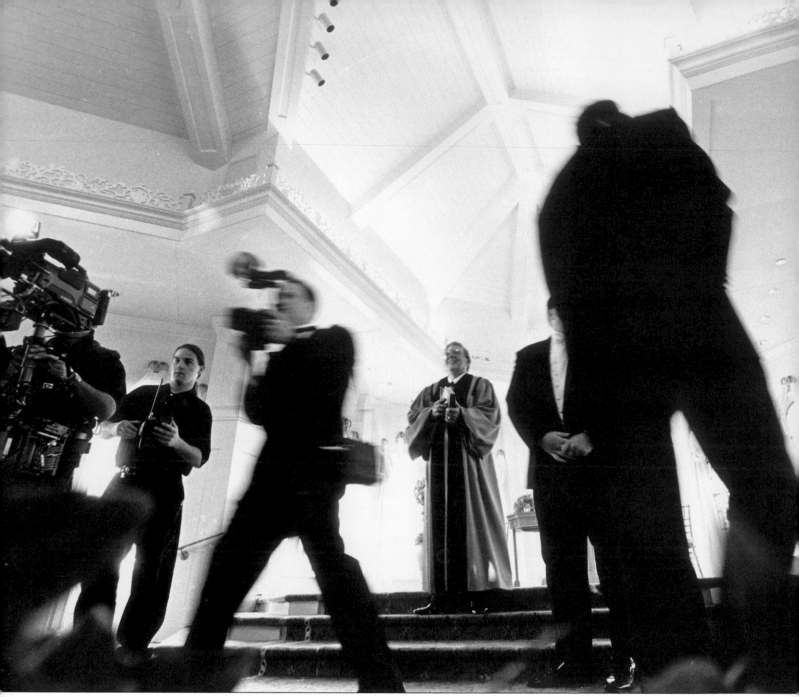

series. They were used in action sequences at the villain's hideout. Now couples believe the technique is creative, expressive and cutting edge. In some theories of composition, angles are believed to convey action and a sense of tension or uncertainty.

❏ Silhouettes
Silhouettes have been part of the portrait artist's repertoire for centuries. They are, in some senses, the opposite of a portrait because little or no information about the face is revealed in the picture. Yet, silhouettes please some brides. They are effective at conveying a likeness, yet provide a sense of mystery. Preparation for married life can be very mysterious and full of wonder, so it seems appropriate that such a technique would be used to display visually the same sense of mystery.

Above: For this picture of a wedding, which looks like a news event, the photographer placed a radio controlled camera with a 24mm lens at the bottom of the stairs and titled the camera upward. Photo by John Unrue.

Opposite: Tilting the camera moved this portrait out of the ordinary classification and into to the small group of memorable pictures selected for this book. In this case, a bit of tension was added to a very still portrait. Photo by Phil Morgan.

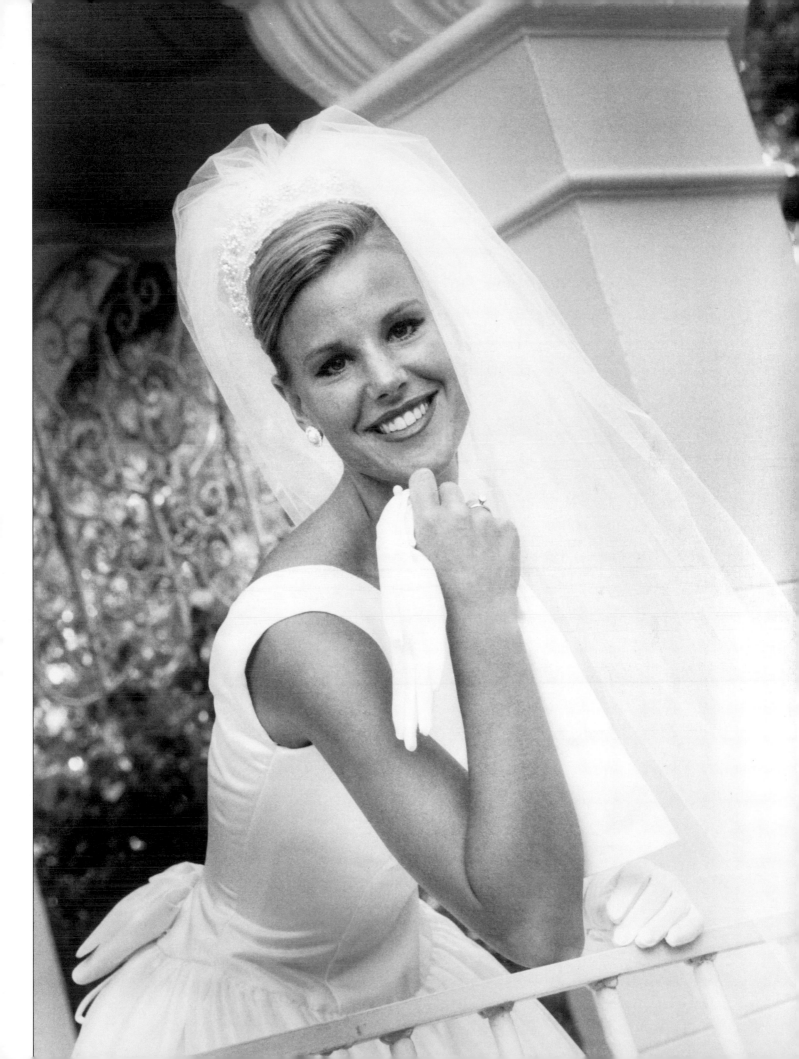

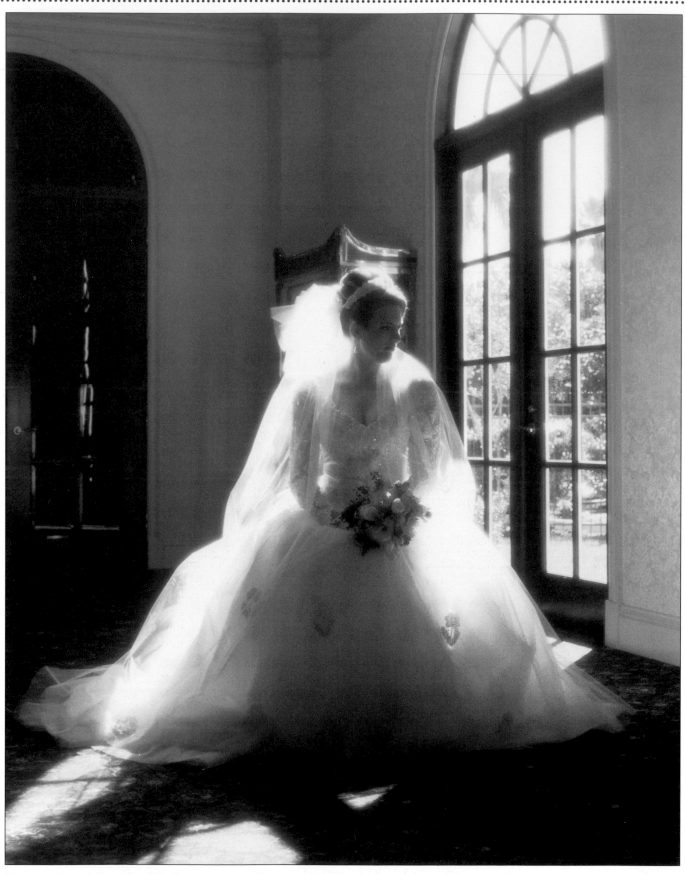

The attraction of silhouettes is their air of mystery. Viewers spend time trying to see the face and understand the person in the image. Photo by Carol Andrews.

◻ Sunsets and Shutter Drag

Sunsets are romantic. A couple with a sunset in the background is an icon of romantic love. Use the shutter drag technique to balance the sunset exposure with that of the flash. To do this, set the shutter to give the sunset nearly the same exposure as the flash provides for the couple. Exposures can be many seconds long. In these instances, direct the couple to quickly walk out of the picture after the flash, so they don't blur their image just by breathing and holding still.

Experiment with different shutter speeds. A blurred or streaked image may produce an exciting or symbolic photograph. Film is cheap, so don't miss a creative opportunity. Couples have been known to buy the strangest images — even ones photographers consider mistakes.

The Wheatleys used the scenery and a sunset reflecting off a pond to add romantic elements to what otherwise would be an ordinary formal wedding photo. Photo by Ken Wheatley.

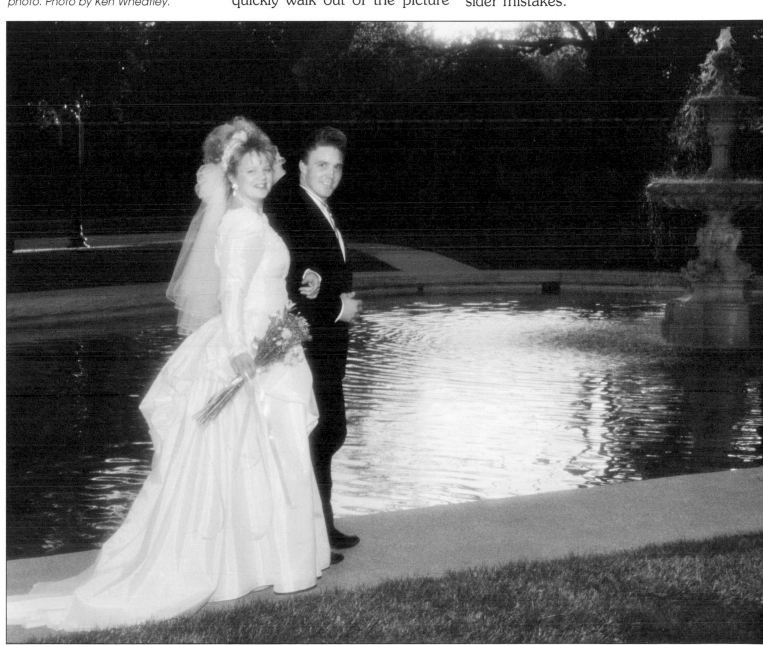

◘ Zooming

A way to center attention and to increase the importance of a picture is to zoom during a long exposure. Zooming imprints streaks into the outer edges of the picture but leaves the center relatively normal. The streaks point to the center and the key element of the shot.

Recall that cartoonists use streaks to portray action or motion in a still picture. The same principle works with photographic images.

◘ Panoramas

Panoramas are a wonderful way to liven up a picture. The 4x6 aspect ratio of 35mm snapshots can become tiring and boring.

Panoramas get "oohs" and "ahs" from viewers because they understand them. They are dramatic, and they mimic the width and height of human vision. Panoramas are an important capability to showcase in a portfolio because they can set you above other, less versatile photographers.

The photographer placed the camera on a tripod and moved the zoom control during a one second exposure. Photo by John Unrue.

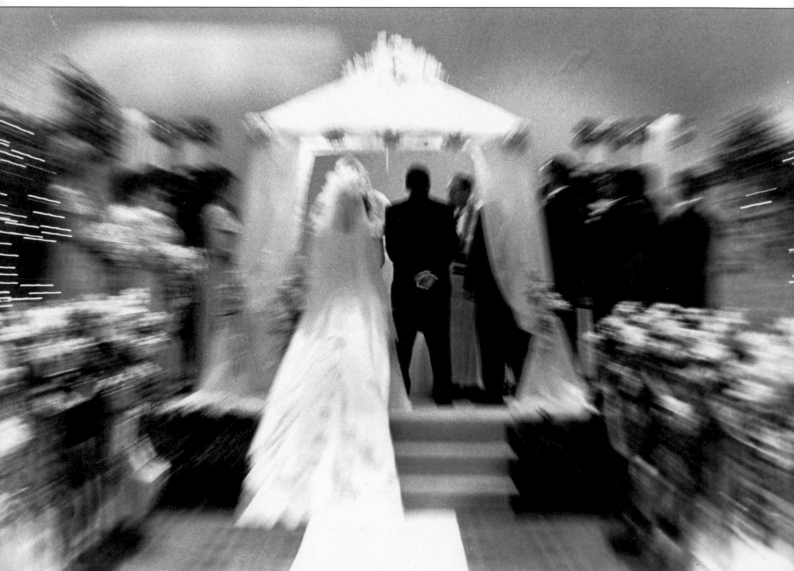

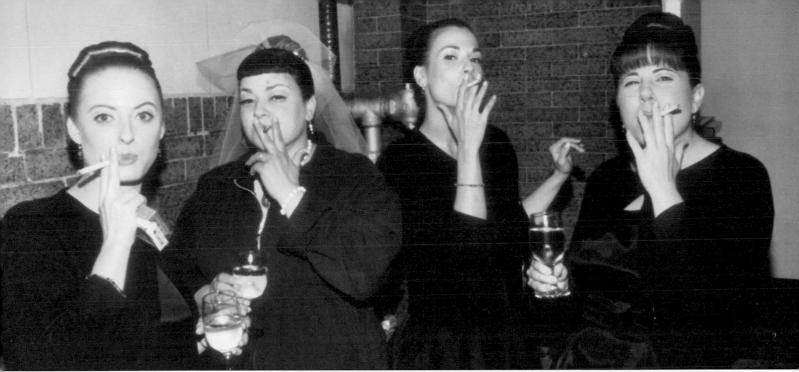

Top: The bride (in the veil) and her bridesmaids take a cigarette break after the ceremony. Panoramic cropping is appropriate because it removes a distracting background and provides an interesting shape for the album. Photo by Suzanne Arndt.

Bottom: A panorama is a wonderful solution for the cake ceremony. The faces and the expressions of the family and guests make this a winning image. The photographer stood on a chair to achieve this aerial view. Photo by Suzanne Arndt.

A panoramic camera is a nice thing to have because they can capture a wide view. Some rotate to capture a full 360 degrees. These expensive specialty cameras are not necessary. Both the panorama examples in this book were shot with a 28mm lens and then cropped to the right shape.

Some album manufacturers offer special double wide pages to accommodate panoramic photos. Any frame shop will custom make a picture frame for such a shot.

◻ Grainy Prints

For generations, photographers and brides were taught that the absence of grain in a print is the sign of both a quality picture and a skilled photographer. Often, this factor was the single method brides used to judge a

photographer. Fortunately, the market is once again changing. Brides are now asking for grainy pictures. They view them as a form of artistic expression. Knowledgeable brides accept the grain that comes with high speed films just in order to avoid the distraction of flash photography.

Kodak T-Max 3200 film is the best film to use to display grain and avoid using flash. Exposures in a church might range from $f1.4$ at 1/60th of a second to $f5.6$ at 1/250th. Each church is different, so careful exposure metering should be performed before the event. T-Max 3200 is too sensi-

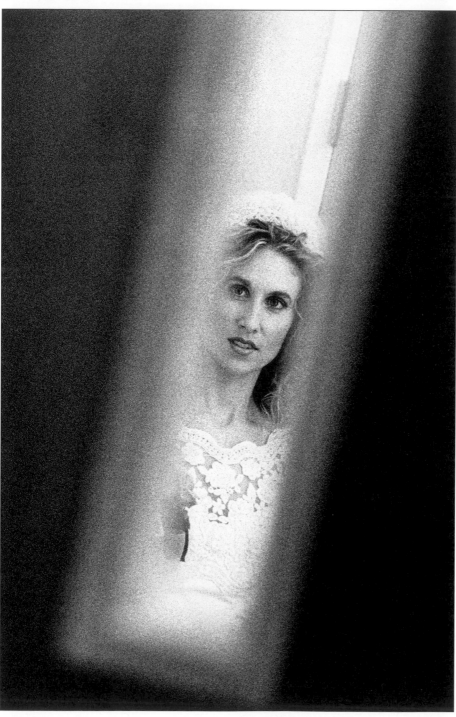

An alert photographer shot this bride through the church door as she walked down the aisle. He used T-Max 3200 to get the grainy effect the bride wanted. Tilting the camera made the picture more dynamic. Photo by Scott Livermore.

tive to use outdoors in bright light. The film also has a very short tonal range, which may surprise some photographers. Shoot some test rolls before using this film at a real wedding.

Kodak publishes methods for pushing T-Max 3200 to ISO 25,000 or ISO 50,000. This allows the film to be used for criminal surveillance. Even this super grainy effect could make an interesting and creative bridal portrait.

◻ Black and White

Black and white pictures are so "in" that many couples insist all their prints be black and white. Black and white processing is more expensive than color because few laboratories get enough business to justify buying automated processing equipment. This means black and white processing and printing must generally be done by hand.

An alternative to traditional black and white film is to use a black and white film specially designed to be processed in the standard C-41 color negative chemistry. Kodak, Ilford and Agfa each make such films, which are available in ISO 200 and ISO 400.

Printing these films on color paper almost always results in a color tint – cyan, sepia, green, magenta, red or yellow, depending on the technician operating the printer. Some professionally-oriented labs offer the photographer a choice of tint. While these specialty films don't produce neutral gray prints from color printing paper, many couples will choose a tinted print over a traditional print. These negatives can also, of course, be printed on traditional black and white paper.

Sometimes, the parents want color pictures while the couple wants monochrome. The only solution in this situation is to shoot in color and print in both color and black and white.

"Black and white pictures are so 'in'...."

2
THE NEW
WEDDING STYLES

◻ Photojournalism

The leading new wedding photo style, photojournalism, derives from the established traditions, philosophy, methods and techniques of photojournalists. The style concentrates on capturing peak action and emotions. Pictures convey emotions by focusing on faces, hands, and body language – the ways that humans display emotions.

Wedding photojournalists strive to tell the central point of the wedding story with the images they create. A bride and groom facing the camera while standing in front of an altar tells the viewer that there has been a marriage, but little else.

The photojournalism style is best executed with 35mm cameras. These small cameras offer the fast operation, light weight, and variety of lenses and accessories that are essential for capturing images as they happen. 35mm film is also less expensive than larger format film, making it economically feasible to shoot a large quantity of images. This is especially important for photojournalism, since shooting as events unfold means working in available light with active, unpredictable subjects. Unlike traditional photographers, wedding photojournalists don't have to tell the story in just one picture. Wedding shooters can use a whole wedding album, usually up to 144 pictures – similar in quantity to the average fine art photography book.

◻ The Documentary Style

Documentary photography is philosophically opposite from the photojournalism style. Photographers practicing the documentary style (outside of the wedding business) often approach a topic with firm opinions. They use their photographs to prove or support their opinions. This approach was once considered unethical by many photojournalists. Photojournalists historically

"The style concentrates on capturing peak action and emotion..."

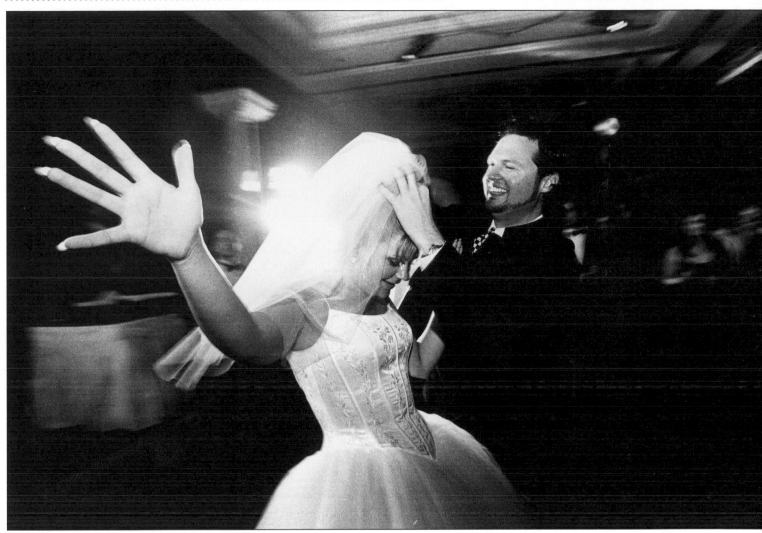

Here a groom adjusts the bride's veil during the reception. A slow shutter speed was selected in combination with the flash so some blurred motion would be recorded. A 20mm lens exaggerates the perspective. Photo by John Unrue.

believed they can make unbiased photos that tell a news story fairly. This belief is fading among many working news photographers.

Leading proponents of documentary photography included Lewis Hine, Jacob Riis, Matthew Brady, Walker Evans, and Dorthea Lange. Each of these photographers sought to reveal and change social conditions. Many modern documentarians see their function as one of revealing hidden truths through pictures.

Dianne Hagaman, a Seattle photographer, uses photogra-

phy as a revealing and persuasive tool to support her point of view. She leads viewers to a conclusion through comparison, contrast and symbolism. As part of a personal project, she decided to photograph a bride. Says Hagaman in her 1996 book *How I Learned Not To be A Photojournalist* (University of Kentucky Press), "I sought out aspects of ceremonies that involved the relationships of women and religion, situations that expressed ideas about a woman's role and place."

Photographers working in the documentary style also take

29

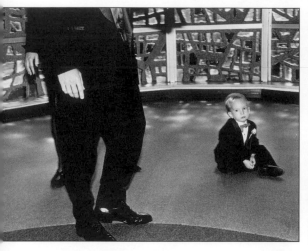

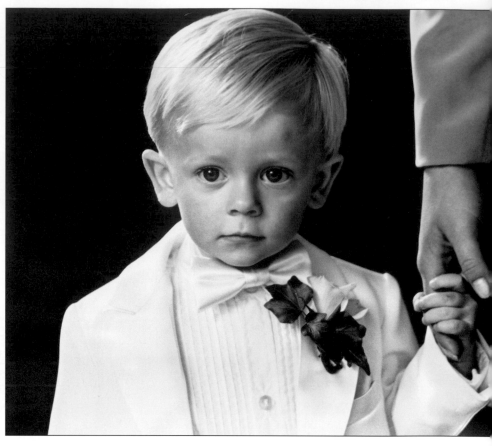

The expression on this boy's face as he clutches at an adult telegraphs the child's feelings to the viewer. The addition of the two other pictures completes the impression that children give adults a hard time at weddings. The message is stronger using three pictures than it would be with just one. Photos by John Unrue.

advantage of what is called the "third effect." The third effect describes what happens when two pictures are displayed side by side. The messages each show individually combine to give a third message which may be different than those conveyed by either shot separately. For example, a baby picture displayed next to a picture of a rat in a trash pile might imply that rat infested trash is hazardous to cute, cuddly babies.

The third effect also can occur within a single picture. Advertisers use this phenomena daily by picturing a respected celebrity next to a product. The implication is that the celebrity

uses the product. In reality, the celebrity might not ever use that product.

A closely related concept is context, which documentary photographers use to link objects to activities and environment. This places additional emphasis on the environment. Photos tend to show the sky, ceilings, walls and floors, tilted horizons, and quirky details. As a practical matter, documentary wedding photography places more emphasis on the environment surrounding the wedding and reception than do other styles. To achieve this view, the photographers make extensive use of wide angle lenses.

"... link objects to activities and environment."

Documentary photography tends to follow a few widely accepted conventions that help identify the style:

- Flash photography is never used because it changes the lighting of the scene.
- The goal is to examine truth, so pictures tend to be hard, contrasty, sharp and gritty.
- The images do not necessarily flatter the subject.
- Conflicts, fights, tears and disasters are faithfully recorded.

- Color pictures are rare. Documentarians say black and white strips away superficial elements and exposes reality.

Despite its often harsh realism, the visual style of documentary photography can be applied to weddings without the negative connotations sometimes attributed to it. The photographer must genuinely believe weddings and their associated traditions are positive aspects of society and show this in his or

A bride inspects the dining hall before the ceremony. The environment is the most important element of this picture. Photo by Carol Andrews.

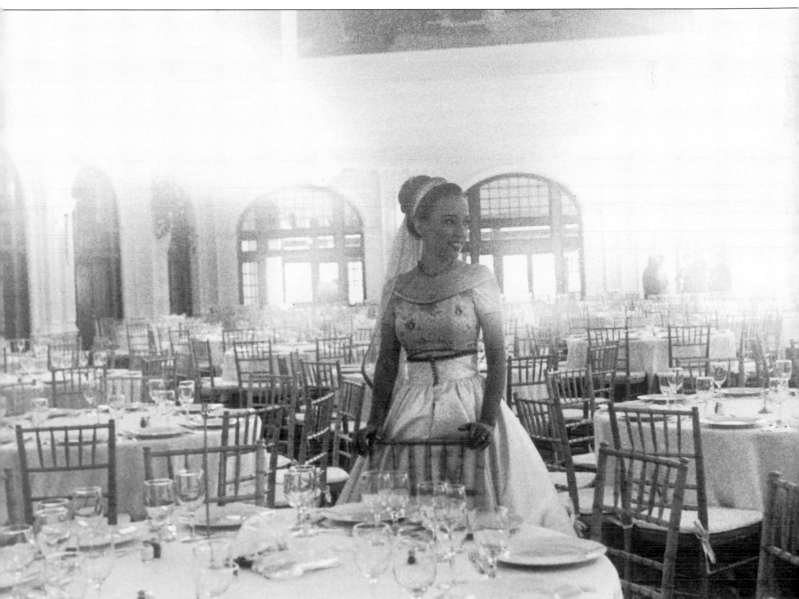

her image. Attempts of photographers to hide their feelings and opinions of weddings usually fail, and the photographic results may disappoint the client and the artist.

◘ Fine Art

The question of whether wedding photos can be considered "fine art" is beyond the scope of this book. The fact is that some photographers are successfully selling their work as fine art is answer enough.

While "fine art" is difficult to define, some characteristics are common. Fine art wedding images normally feature a strong graphic design. Black and white images are the standard. The style also tends to be highly creative. Handcolored black and white prints are common, as are toned prints (with sepia toning being very popular). Polaroid transfer images are also popular, as are grainy images shot on high speed film and infrared images.

The presentation of the images to the client is also important in this style. Some of the characteristic of fine art presentations include:

- Often, the edges of the negative are printed in the frame, creating an irregular black border.
- Pictures are delivered fully matted in special presentation boxes that double as storage boxes.
- Standard print size is 4x5.

- Film and prints are archivally processed by hand.
- Fewer prints are presented (about 12 on average).
- Large framed prints sometimes feature deckle edges (ragged and torn edges).

Any attempt to precisely and absolutely define photographic styles so that they can be easily identified is doomed to fail. There is a great deal of overlap between styles. Plus, styles change over time. Just as the old formal style of wedding photography is fading so will today's styles evolve into something new, or, perhaps an old style will be revived.

This picture features several of the characteristics of fine art, including graphic composition, black borders and a black and white picture shot on infrared film. Photo by John Unrue.

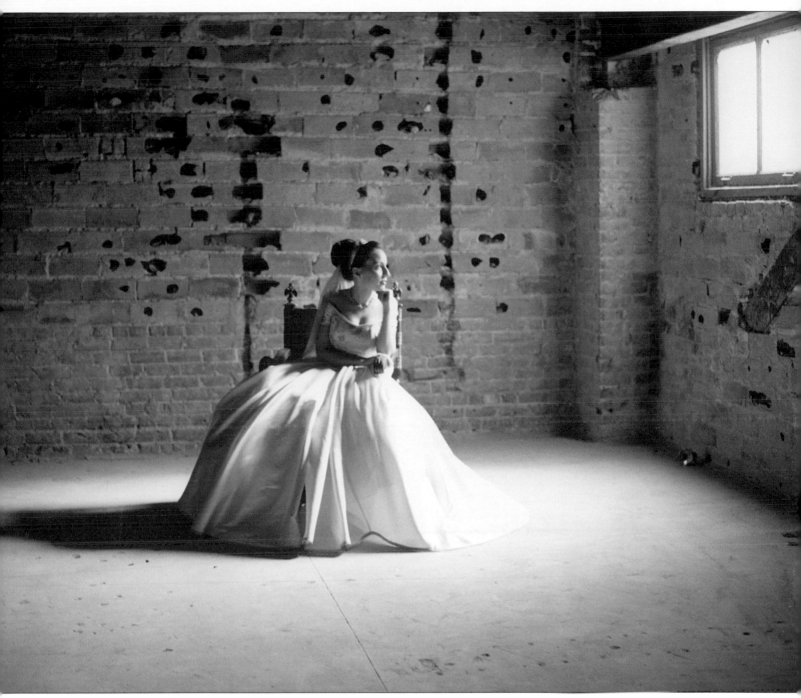

The location put this picture into the avant garde class. This bride was passionate about restoration and preservation of historic buildings. So Andrews photographed her inside a building under renovation. Notice the holes in the brick. The image was made after the wedding so it didn't matter that dirt from the construction covered the gown. Photo by Carol Andrews. For more on this topic, see page 38.

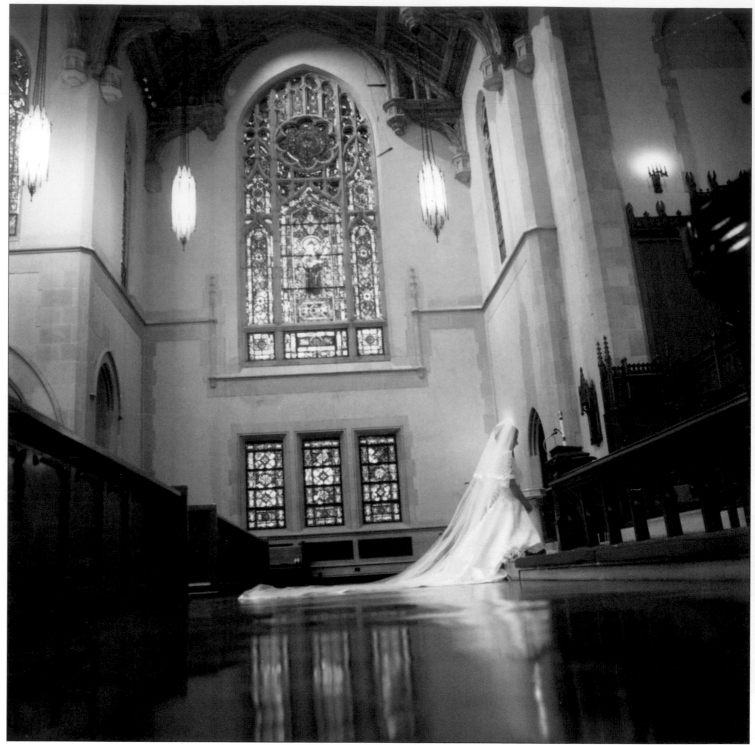

Above: Andrews mixed some of the avant garde style (titled horizon) with the architectural photography style to produce the memorable image of a bride in prayer. Photo by Carol Andrews. For more on the architectural style of bridal portraiture, see page 35.

Opposite: Although she constitutes only about an eighth of the frame, the bride was very happy with this portrait in the architectural style. Photo by Carol Andrews. For more on the architectural style of bridal portraiture, see page 35.

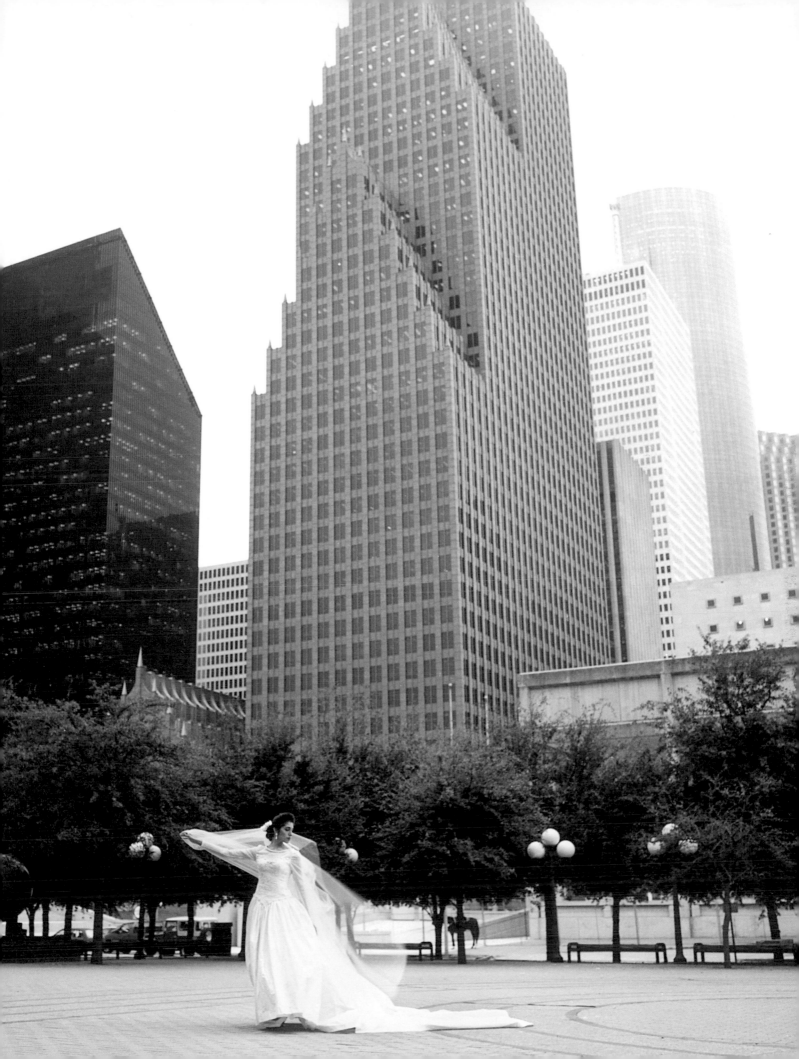

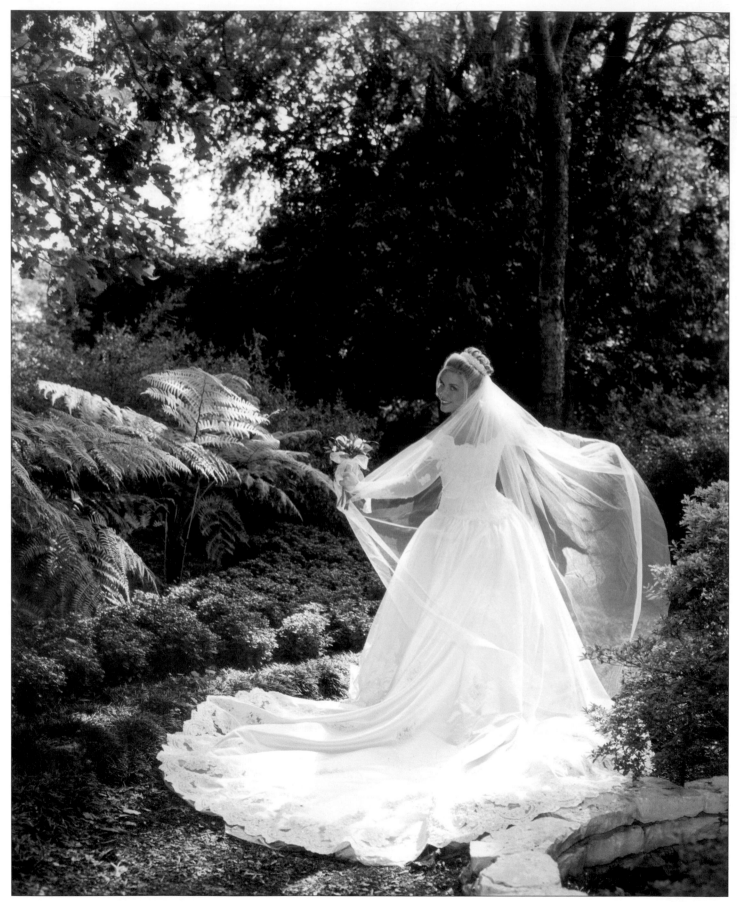

This bridal portrait photographed in the Dallas Botanical Gardens features an attention-getting pose. Photo by Janice Wheatley. For more on posing bridal portraits, see page 40.

BRIDAL PORTRAITURE STYLES

Several styles of bridal portraiture have emerged in the past few years. Today's best bridal portraiture is shot on location. Sometimes the environment is more important than the bride. All the new styles capitalize on the freedom that photographing outside of a studio provides.

The old style of photographing the bride – facing the camera in a full-length picture that features the gown's train – is vanishing. These pictures, traditionally shot in a studio or at the altar, are not seen today in the portfolios of leading photographers.

However, among the new styles, bridal portraiture is the last bastion of posed photography. This is because portrait sessions offer the time needed for precise posing and lighting.

In a major break from tradition, bridal portraiture now also includes the groom – if the bride is not superstitious about her future husband seeing her in the wedding gown before the ceremony.

□ Photojournalism

The photojournalism style of bridal portraiture focuses on the bride's face and relegates the dress to secondary importance. The background is considered only if it is distracting or enhances the picture.

In rare cases, backgrounds and other elements help tell the bride's story. Signs which help define the wedding site are good elements to use. Other props may also contribute to storytelling.

Old European portraits included such things as jewelry, dogs, books, horses and buildings to visually tell the viewer who the subject is as well as her social status. Illustrators still use these symbols and others to tell their stories. The same techniques work in the photojournalism style of bridal portraiture.

"... bridal portraiture now also includes the groom..."

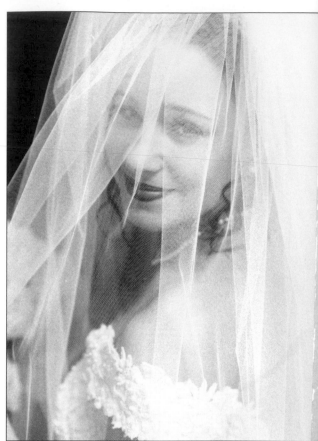

Top Left: Some bridal portraits include the groom. Note that here the bride is emphasized by placing her in front. Photo by Carol Andrews.

Top Right: This portrait of a bride adds mystery and romance by placing the veil between the viewer and the bride. Photo by Nikky Lawell.

A soft focus filter, white roses, veil and pearls distinguish this portrait. Photo by Janice Wheatley.

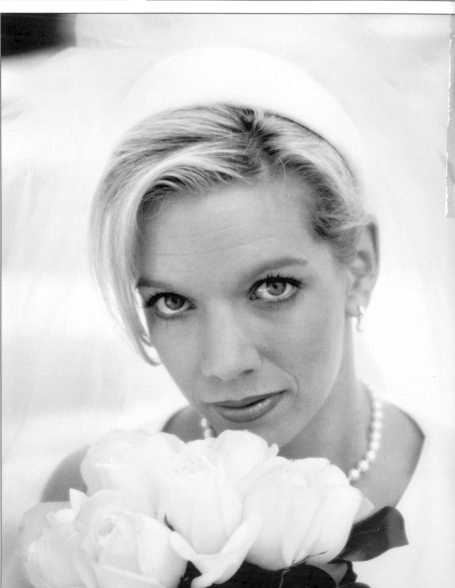

◻ Architectural Style

A popular style of bridal portraiture incorporates architectural elements into the composition. Often, the bride is a small element in the frame. The architectural details are used to focus attention on the bride or illustrate an activity the bride is known for or interested in. For example, if a bride is an artist, she might be photographed in front of an art museum or with some outdoor sculpture.

Perhaps the popularity of the architectural style is due to the visual or graphic nature of buildings. Some buildings scream for attention. By placing a bride in

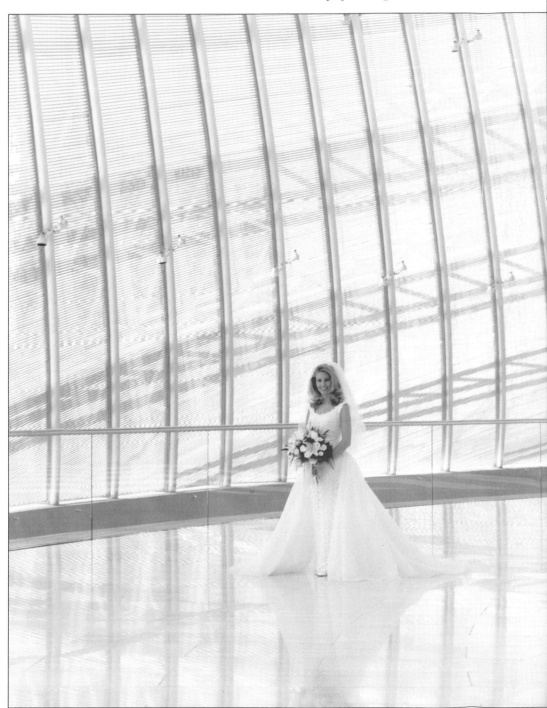

The Morton Meyerson Symphony Hall in Dallas is the site for this portrait. Curving lines surround the bride and focus attention on her. The lines also contrast nicely with the curves of the bride and the softness of the gown's train. The original color picture featured a limited color range from white to brown to touches of red. The photographer won the "Photographer of the Year" award in 1998 from the Dallas chapter of the Professional Photographers of America. Photo by Fran Reisner.

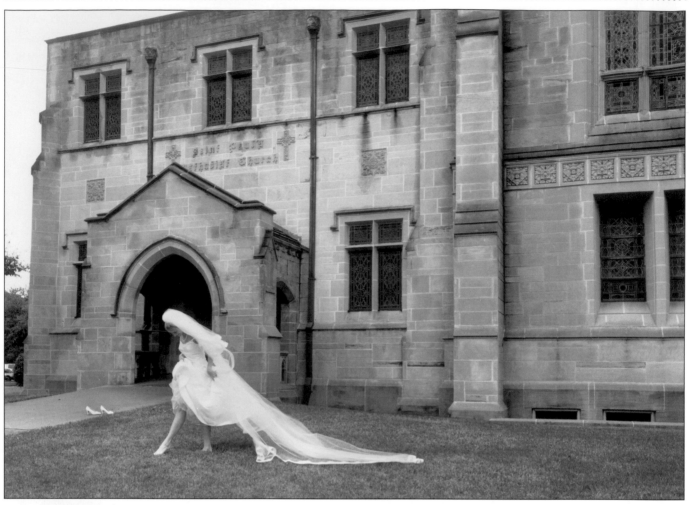

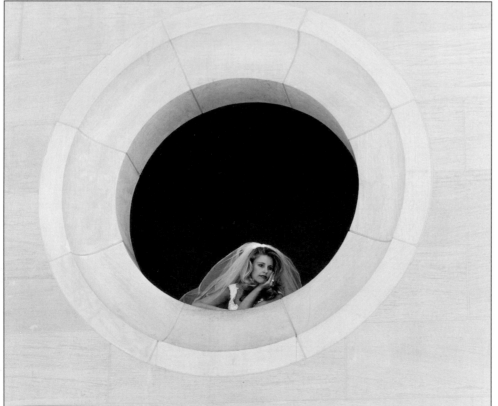

When this bride, a dancer, wanted a unique portrait, Andrews had the woman frolic bare-footed in front of the church. Photo by Carol Andrews.

This architectural photo differs from others in this section because of its simplicity and the way the window directs attention to the bride's thoughtful expression. The circle of the window is symbolic of the unity of marriage and reminiscent of a wedding ring. Photo by Fran Reisner.

a picture with a building or other architectural element, the photographer uses attention-grabbing aspects of the structure to direct a viewer's gaze to the bride.

◻ Romantic Style

In romantic portraiture, the idea is to portray the bride as absorbed in the romance of the wedding and her new life with her husband.

Romantic portraiture is identified by its soft focus and the fact that the subject never faces the camera. Frequently, the bride's eyes are closed, or she is gazing at a bouquet, the ring, or flowers. The pose in such portraits promotes the impression of the bride in a dream world. She may recline on a pillow or chaise. This style never displays bright or intense colors.

Romantic bridal portraits are frequently created in a garden or other place that holds special meaning for the individual bride. Backgrounds are usually out of focus or high key.

The tulle covers the bride's face to add an aura of mystery. Props, such as extra tulle, are very handy to have. This portrait was photographed in a studio. Photo by Carol Andrews.

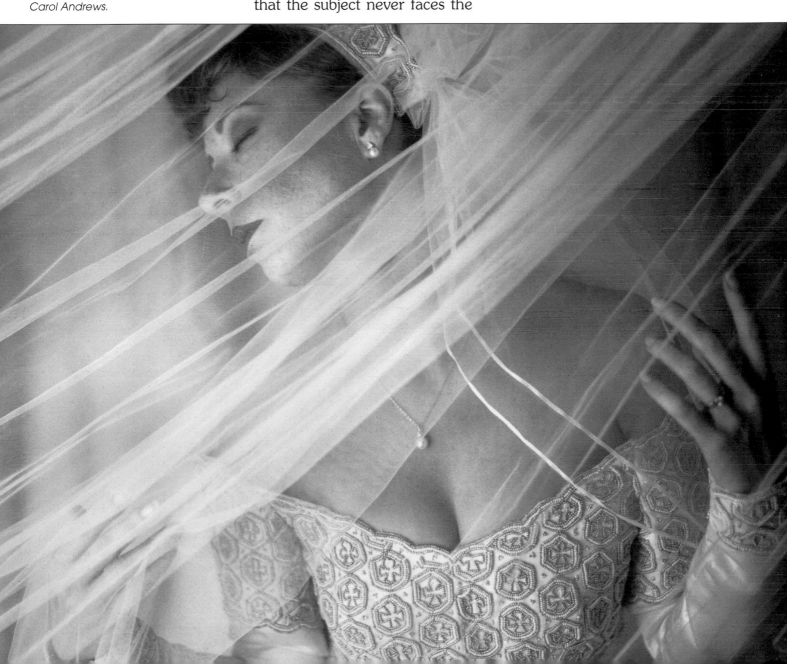

Left: In the romantic style, it is not necessary to show the bride's full face. Windows provide very flattering lighting, but it is up to the creative photographer to add the elements that make an image romantic. Photo by Carol Andrews. Right: An unusual gown such as this must be displayed to show its features. Andrews chose to show the split in the dress. Photo by Carol Andrews.

◻ Fine Art or Avant Garde Style

The fine art or avant garde style is innovative and full of unexpected elements. For example: if the expected image is that of a bride's full face, the artist will place it in silhouette, or turn the bride's back to the camera, or blur the image to show motion. A clever photographer might also tilt the horizon for variety, change the color balance to suggest emotions, or shoot from unexpected angles.

The avant garde style is closely related to fine art photography because it deliberately sets out to break the rules of bridal portraiture. The variation from the norm is more extreme than in fine art. An example may include an unexpected environment, a titled horizon, an unusual photographic effect or a special process, or even paint-

ing over elements of the print. Selling fine art is easier when the client and her parents are well educated or have some exposure to art. For some clients, ragged or black print borders will help them identify the pictures as fine art.

A bride that expresses a desire for pictures that are unique will accept fine art bridal portraiture. However, parents may have different expectations. Discover their expectations. To fulfill the needs of both the bride and the parents, it may be necessary to create bridal portraits in two different styles.

A third picture may be necessary if the local newspaper has rigid standards for picture use. Many larger newspapers will only use mug shots. Space limitations force metropolitan daily

"... it may be necessary to create bridal portraits in two different styles."

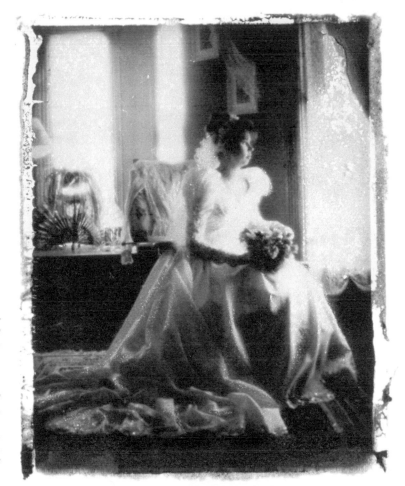

The Polaroid transfer technique produces a different result with every attempt. Janice Wheatley extended the method to express her feelings by hand painting the 4x5 inch print. Photo by Janice Wheatley.

The location put this picture into the avant garde class. This bride was passionate about the restoration and preservation of historic buildings. So Andrews photographed her inside a building under renovation. Notice the holes in the brick. The image was made after the wedding so it didn't matter that dirt from the construction covered the gown. Photo by Carol Andrews.

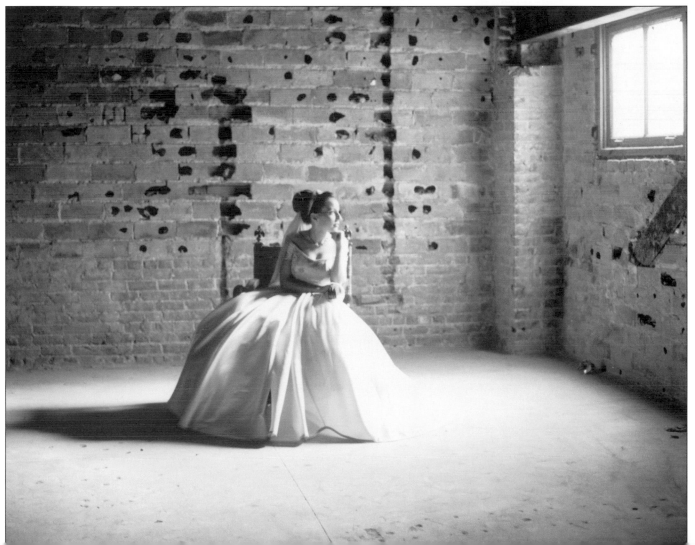

newspapers to run the picture 1/2 or one column wide.

Fine art and avant garde bridal portraiture demands and encourages the highest level of creativity. This specialty provides photographers a degree of freedom not available in any other style.

◻ Advertising Style
The advertising style of bridal portraiture is a survivor from the old school of strictly posed portraiture. The style derives directly from that used by photographers who create images for wedding gown advertisements. This style responds to the fact that brides often express a desire to be posed the same way as the model in the ad which featured the dress she bought.

Dramatic lighting plays a role in creating successful portraits in this style, so consider using spotlights or lights with colored gels. The backgrounds you use must force the viewer to look at the bride. Alternately, you may wish to use odd or unexpected accessories.

Advertising style poses must grab the attention of the viewer. Because the poses can be complex and difficult, some brides end up looking awkward if they are not naturally graceful or trained as a model or dancer. Photographers must especially be alert for awkward poses, and be capable of rectifying the problem or creating an alter-

nate, more graceful pose for the portrait. A good way to learn the current posing styles is to study the pictures in bridal magazines.

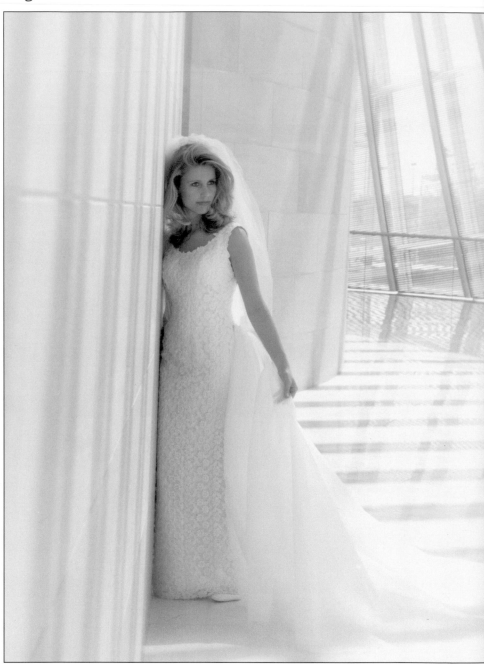

This picture shows the wedding dress very well, just like in the magazines. Photo by Fran Reisner.

Organization and Equipment

4

PLANNING THE SHOOT

Preparation is as important in the new styles of wedding photography as it was in the formal style. However, the goals are different because the results must be different.

Before the ceremony, meet with the bride, groom and parents to learn the schedule of events for the wedding day. The sequence will tip you off as to where picture possibilities exist. The clients will determine which pictures they insist on having and who the special people are that will attend.

Take notes, write down their desires, and review the list with them. Describe your shooting style for the client so there are no surprises or disappointments. Later, type up a shooting list so you don't forget the client's special requests.

Visit the reception site and wedding site several days before the event. The visit is a scouting opportunity. Measure the available light. Study the rooms, noting the good and bad backgrounds both inside and outside.

Shoot a test roll of film with flash, if you plan to use one. Shoot a second roll using only available light. This is the best way to discover lighting conditions and problems. A one-hour processing lab will process the test pictures quickly enough for you to have time to resolve any issues.

During your visit to the ceremony site, check with the clergyperson for any restrictions he places on photography during the ceremony. Knowing the ground rules allows time to adopt work-arounds such as tripods and remote control cameras. This visit is your best opportunity to establish shooting positions and determine which lenses are appropriate.

Shortly before the ceremony, pre-position film and batteries

"... discover lighting conditions and problems."

at your shooting locations so that you don't have to search for these supplies or carry a heavy camera bag around the church. If you have photographers assisting you, also position them appropriately before the ceremony begins.

Leave the ceremony just before it is finished so you can take a position that will allow you to photograph the couple as they walk down the aisle and out the door of the church.

The reception is where a photographer makes or breaks the project. Shooting too much film can drive expenses so high that you lose money. On the other hand, being stingy with film would result in lost shots and an inferior final product. This is how pre-planning saves the day. Pull out the shooting list and stick to it, but don't pass up the unexpected.

It's a great idea to have an accountant calculate your real cost for shooting a wedding so you know exactly how much each roll shot really costs you. The figure will include film, processing, enlargements, assistants, cameras, and other items of overhead.

"Leave the ceremony just before it is finished..."

5

SELECTING EQUIPMENT

☐ 35mm Format

For generations, shooting with a large and complex camera was part of the marketing of wedding photography (the logic being that if you owned and could operate a large, expensive camera, you must be a good photographer). However, with today's vast improvements in photographic technology, the size and price of the photographer's camera is no longer an indicator of the photographer's skill or talent. While medium format is still a popular choice among wedding photographers, the 35mm camera has begun to be more commonly used.

Shooting in the 35mm format has a number of appealing advantages, from greater portability to cost savings. To test the possible differences in image quality (normally the reason medium format is selected over 35mm), we placed an 8x10 print made on ISO 400 roll film (120 size film shot with our

medium format Pentax 645) next to an 8x10 print shot with 35mm ISO 160 film. We had trouble seeing a difference in film grain between the two prints. Our non-photographer friends could not tell the difference at all. The lesson we learned is that to achieve medium format camera quality with 35mm film, all we need to do is use a 35mm film with half the ISO rating (as our favorite 120 film).

There are also cost savings to be considered. We spent $389 in 1999 to purchase, process and proof ten rolls of 36 exposure film and then print 24 8x10 photographs for an album. It would take twelve rolls of 220 film to shoot the same 360 pictures, and we'd spend $412 to purchase the film, process it, proof it and make 24 8x10's for the album. We thereby saved $23 by using 35 mm film. This means that by using 35mm, we can save the bride and groom $23 and still

" ... the 35mm camera has begun to be more commonly used."

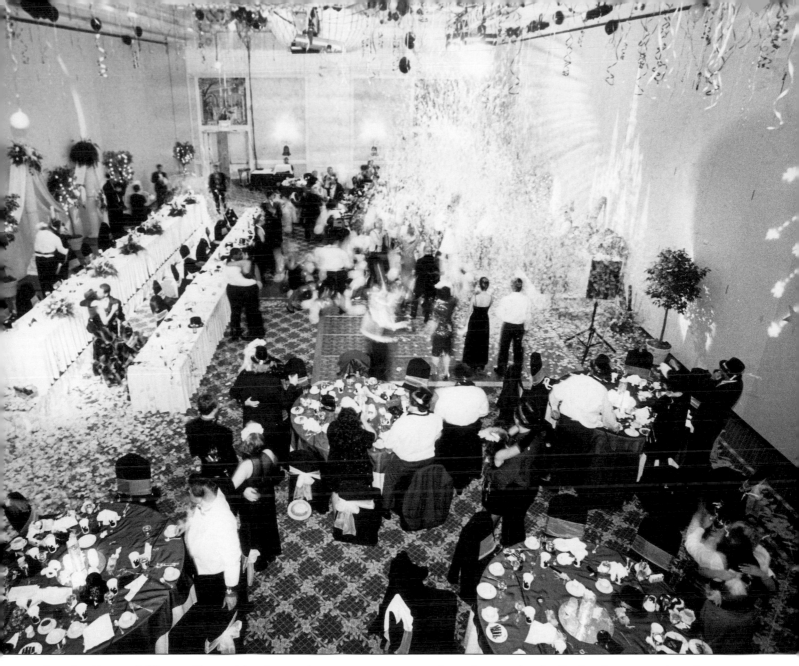

A radio triggered Nikon with a wide angle lens caught this wedding reception at the stroke of midnight New Year's Eve. The camera was mounted on the same bars that supported the theatrical and dance lighting in the room. The camera was mounted and tested hours before the reception began. Photo by John Unrue.

have the same amount of profit from the assignment even before we calculate the various overhead and camera expenses. Our professional quality Canon 35mm system was also significantly less expensive (about 60-70% less) to purchase initially than a comparable Hasselblad medium format system.

◻ Remote Flash Triggers

Sometimes techniques used by professional photographers decades ago disappear and then reappear. This is the case of multiple flash photography. On-camera flash has been popular in recent decades because of its mobility and low cost. But in the past few years, technology has changed, and multiple flash photography has made its return.

Using multiple flashes set strategically around a room eliminates the ugly black background common in on-camera flash photos. Historically, multi-flash set ups required stringing synch cords on the floor and around

the room. People stepped on the cords, tripped over them, and occasionally brought the flash crashing down. Today, microelectronics eliminate the dangerous, unreliable synch cord. Three different methods are available to trigger remote flash units.

The least expensive is a photo-electric sensor that senses when the main flash has been fired and instantly triggers its flash. Several problems are evident with this method. First, any-body with a point and shoot camera and flash can trigger the remote unit merely by using his flash. This results in wear on the batteries as well as failure of the flash to fire when expected (if it is still recharging from a previously triggered discharge). The second issue is that the sensor might be too far from the flash to be triggered or the sensor may not be aimed at the on-camera flash.

Infrared flash triggers exist to solve the issue of accidental discharge caused by amateur cameras. But the sensor must still be pointed at the on camera flash and be in range.

The most expensive (but nearly foolproof) solution is triggering the flash by radio. Some radio slaves have ranges approaching 1/8 of a mile. Multi-channel radio triggers can control multiple remote cameras and multiple flashes separately. Radio triggers also do not need to be aimed at the camera to work.

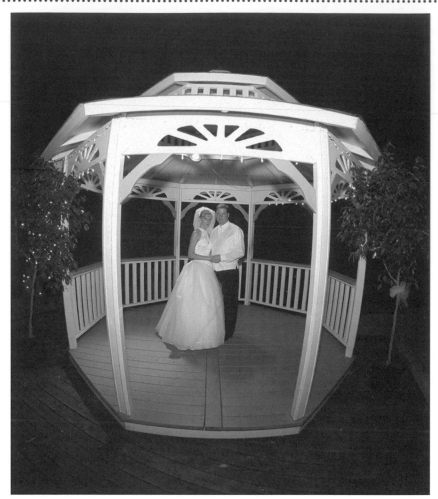

You can buy a nice used car for the price of a medium format fisheye lens or you can rent a Canon 14mm fisheye lens for the weekend for a few dollars, as Ken and Janice Wheatley did to shoot this image. Photo by Ken Wheatley.

◻ Digital Cameras

Since their introduction, digital cameras have improved dramatically in quality, and dropped just as dramatically in price. In just a few years, the price of digital cameras with the resolution of ISO 400 35mm film will be close to the cost of professional level Canons and Nikons. When this happens, it will have a very significant impact on the wedding photography industry and how professionals photograph weddings.

While it is still far from standard, some wedding photogra-

"The savings from going digital can be astounding."

phers are already using medium format digital camera backs for posed pictures and the high end Kodak digital cameras for special effects. The technology is improving every day, as are the options available to photographers wanting to shoot digitally.

The savings (in film and processing) from going digital can be astounding. With a computer in your office, you can enhance photographs, crop, and print your images right on the desktop. With a few thousand dollars worth of home computer equipment, a busy photographer can save tens of thousands of dollars in processing every year. Plus – no more film lost or ruined at the lab!

An added bonus is the speed at which clients can expect to get their images – days instead of weeks. While still cost-prohibitive for most, the day isn't far off when it will be within every photographer's reach to take a portable computer and printer to the reception in order to show and sell high quality prints only minutes after they are shot. Taking advantage of these impulse sales will be a great way to boost profits.

With new products appearing and prices dropping every day, digital photography is here to stay, and adapting to it with updated skills is a challenge that all photographers will need to face. While it might seem overwhelming, digital photography offers financial and creative advantages that can't be ignored.

6

SELECTING FILM

Years ago, there was only one film used to shoot weddings: Kodak VPS. Each photographer had to test the film with his own cameras and processing lab to determine the precise ISO rating.

Today, wedding photographers can choose a range of films from Kodak, Fuji and Agfa. A variety of ISO choices are available. 400 ISO film from Fuji and Kodak are commonly used. 800 ISO is popular with wedding photojournalists, as is 3,200 ISO. The photographer can choose film based on his needs that day and the effects he wishes to produce. Even black and white infrared film is sometimes used at outdoor weddings (or for action photography after the ceremony).

Both Kodak and Fuji cater to wedding photographers. Because weddings constitute a significant percentage of film usage, the companies carefully balance their professional films

so white wedding dresses print as white. This is a very difficult feat to achieve. To ensure the correct reproduction, the companies distribute pre-production film samples to members of several trade associations. Photographers test the film under real-world conditions and report the results to the film companies.

Make sure to weigh all your options before selecting a product. In 1999, Fuji's prices were lower than the comparable Kodak product, but Kodak offered an incentive plan in which photographers earned free Kodak gear or tuition for various seminars.

The lesson is that film options change very quickly. Read the photo trade magazines to stay current and make sure you are using the best product available to meet your unique needs.

"Make sure to weigh all your options before selecting a product."

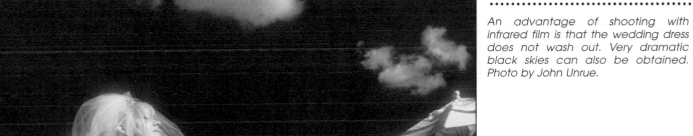

An advantage of shooting with infrared film is that the wedding dress does not wash out. Very dramatic black skies can also be obtained. Photo by John Unrue.

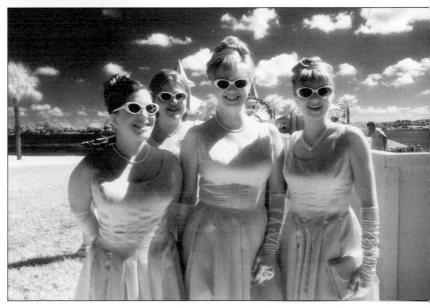

Very bizarre light and shadow patterns sometimes result from the use of Infrared film. The photographer drew on his experience with the film to control the image. He added flair by having all the bridesmaids wear identical sunglasses. Photo by John Unrue.

7

SKILLS AND BEHAVIOR

□ Skills

Wedding photographers using the new styles may shoot as many as five hundred pictures in an eight hour wedding day. That is slightly more than one shot per minute. Wedding day photography, therefore, requires different skills and viewpoints than portraiture.

Photographing a wedding and reception demands absolute familiarity and proficiency with the camera, lenses, film and lights. Busy wedding photographers must know their equipment well enough that they can operate it without thinking about it or looking at the controls.

This intimate relationship with a camera facilitates picture taking under stressful conditions – like wedding days. Knowing her equipment well permits a photographer to push the mechanical aspects of picture taking to the back of her mind and focus on the creative part, capturing the flavor of the wedding and reception on film.

□ Behavior

Taking great photographs is the only fun a shooter should be having at a wedding. Enjoying any other part of the event means she is not doing her job. "We are at a wedding to take pictures, not to eat, dance, drink or socialize," says Suzanne Arndt. A photographer's skill on the job has a strong impact on her success in the wedding industry, but picture taking skill is only one part of the equation that adds to success. Conducting yourself in a courteous and professional manner is another important skill.

□ Enthusiasm

"Photographers should ask themselves if they have photographed 100 weddings or photographed the same wedding 100 times," Suzanne Arndt says. Traditional wedding photography has little concern

"...picture taking skill is only one part of the equation..."

"The new styles of wedding photography provide varied challenges..."

with picturing the soul of the event, or telling the story of the marriage and reception. This cookie-cutter approach can reduce every wedding to the same mechanically-photographed sequence of picture sale opportunities. This can lead to stale images and a bored, unenthusiastic photographer who would rather be somewhere else.

The new styles of wedding photography provide creative opportunities to keep photographers enthusiastic, and clients happy. A traditional photographer might record the bride and groom, the couple with one set of parents, the couple with the groomsmen, the couple with the bridesmaids, the couple with the preacher, etc. The number of possible combinations is big and boring. Taking a more creative approach, the photographer could break the wedding party into little groups and loosely stage a series of natural-looking images. He could add motion, try a unique lens or special film (such as infrared or high speed film), or even use a zoom technique. It all means more images to capture the essence of the wedding, and more images to sell to your clients.

Achieving the New Styles

8

COMPONENTS
OF THE NEW STYLES

□ **Storytelling Elements**

The new techniques go a long way toward breaking the boring pattern of wedding photos. New styles also demand new approaches and new attitudes toward couples.

Some styles focus on telling the story of the couple and their wedding day. Through this approach, the story of the lovers is revealed to anyone looking at the picture album. Some wedding photographers promote this storytelling concept to clients by calling the picture albums "Storytelling Albums." In storytelling albums, the pictures are displayed in chronological order as a storytelling device.

Storytelling albums and storytelling through pictures is so popular that the Professional Photographers of America (PPA) call themselves "The World's Greatest Storytellers." The association even renamed its magazine, now called

Professional Photographer Storytellers.

The storytelling wedding album follows the time line of the wedding day, beginning with breakfast at the bride's house and finishing with the newlyweds entering their motel room.

Storytelling is not limited to strict time sequences. Before and after pictures, detail shots and portraits can be inserted anywhere the photographer deems appropriate. There are few rules to storytelling.

□ **Emotions are Paramount**

A key to telling a wedding day story in a modern photographic style is to capture the emotions of the people involved. Don't be afraid to show the full range of emotions at the wedding – not just the happiness. The stress of the wedding and a changing life can cause some people to cry or argue. These activities should be photographed. A few weeks after

"Some styles focus on telling the story of the couple..."

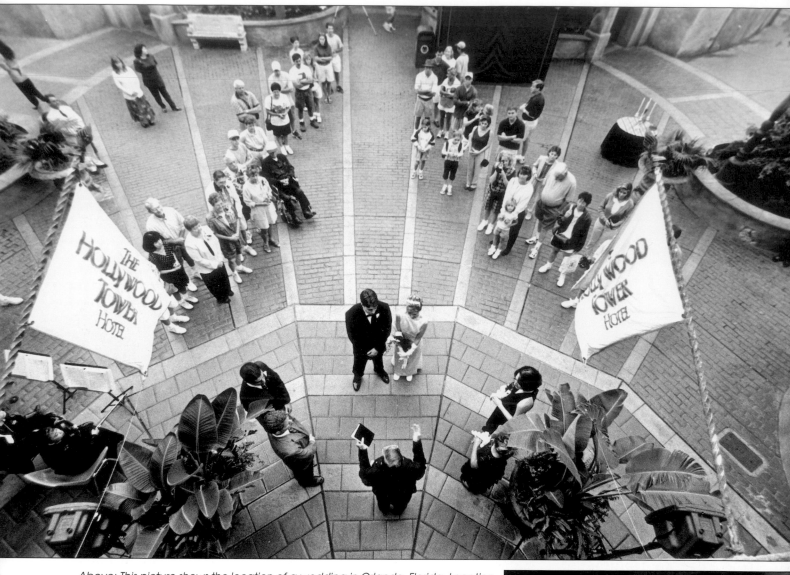

Above: This picture shows the location of a wedding in Orlando, Florida. Location setting shots orient the viewer. Scene-setters like this can be used to start a picture sequence containing many detail shots. Photo by John Unrue.

Right: The groom's son is upset by all the commotion encountered on the wedding day, so the groom spends some time comforting him before the ceremony. Photo by Suzanne Arndt.

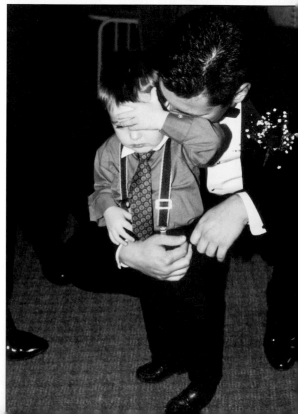

the ceremony, when the pictures have been processed and things have calmed down, the emotional behavior will become part of family lore. Photographs help keep such memories alive.

Some nationally prominent wedding photographers say that unhappy events must not be included in the wedding album and must not even be photographed. They argue photographers need to sell the fantasy of perfect, happy weddings. To the contrary, the tears of mothers and the tantrums of children are treasured memories for the bride and groom. The photographer merely has to handle the crisis with panache and grace.

◻ Show the Romance

American society teaches women to anticipate the wedding day all their young lives. From earliest childhood, women learn about romance and weddings from books, tele-

This un-posed picture is romantic because of the couple's expressions. They are clearly happy. The pose, with the groom's nose smashed against the bride's forehead, shows the fun and familiarity of the the couple, and makes the picture special. Photo by Suzanne Arndt.

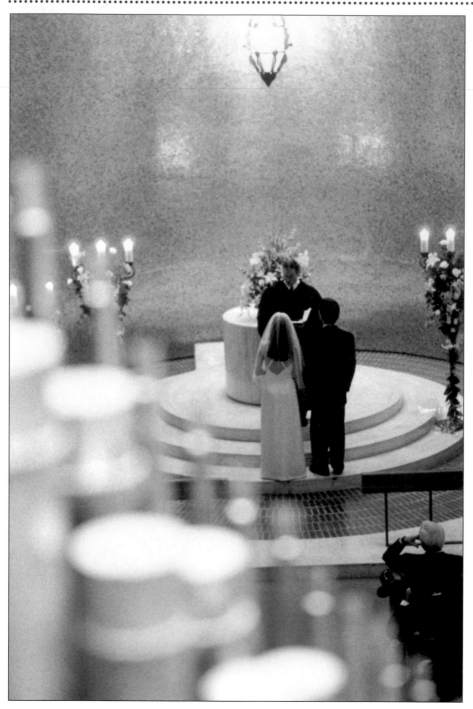

Photographer David Jones took a difficult assignment (photographing the actual wedding ceremony) and added a soft focus filter to make the picture romantic. Photo by David Jones.

vision and movies. Even toys for little girls are often marriage-oriented. Fulfilling the bride's long-held wedding fantasies is essential for satisfying the client.

Many participants in weddings see the entire process as highly romantic. Everyone's attention is riveted on the bride. The groom is essential but secondary in importance.

Photographers should study and learn about romance by reading bridal magazines and romance novels. Learn the clues that will help you indentify romantic moments to photograph. Romantic movies may also provide clues.

56

Any interaction between the bride and groom may be romantic. It is more the subtleties of the action (the glances, tender gestures, etc.) than the action itself which define romance. For example, a couple dancing could be an entirely mechanical act, but if they look at each other, talk or exhibit any other signs of tenderness, then the dance is romantic. Cutting the cake is likely to be an action photo, but when the bride feeds the cake to the groom, the scene could be romantic. The groom smashing the cake into the bride's face, however, is not romantic.

Photographic effects can also help enhance the romantic appearance of pictures. Using soft focus filters, fog, vignetting, warm color lights, blurred motion, shallow depth of field and multiple exposures can help add an air of fantasy and romance.

◻ **Happy People**
Laughter and joy are strong emotions that are easy to find and photograph. Photograph happiness freely. These pictures sell well because they validate the client's belief that weddings are happy events. People like to look at pictures of happy peo-

The photographer took this simple approach when she saw the bride touch her husband's hand to her cheek. The result shows the bride's emotions. Photo By Fran Reisner.

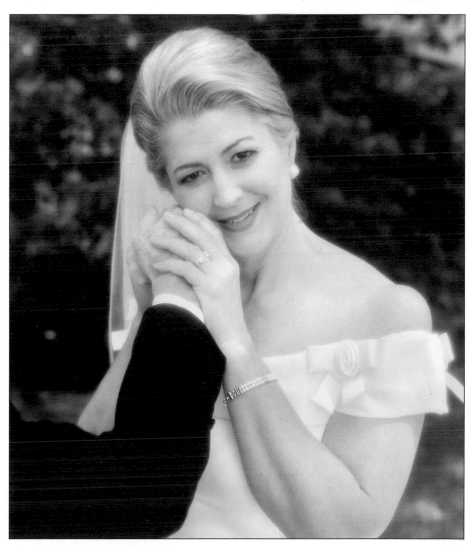

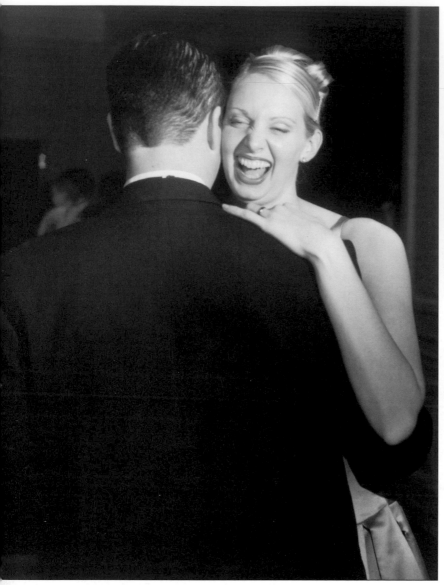

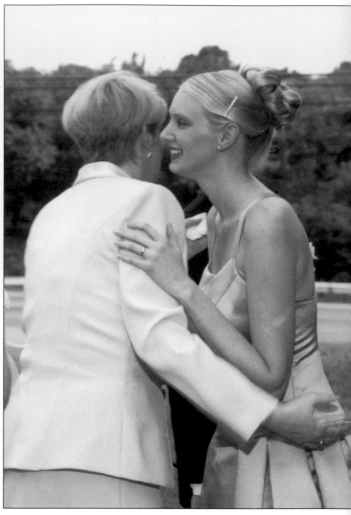

Left: A laughing bride dances the first dance with her husband at the reception. Photo by Phil Morgan.

Right: A mother and daughter hug after the wedding ceremony. Photo by Phil Morgan.

ple. For evidence, just recall how many times you have been told to watch the birdie and smile for the camera.

Joyful photo opportunities can be found any time during the wedding day, but they are most often spotted during the reception because the pressure of performing correctly at the ceremony is over.

Happiness can not be posed. A photographer who tells everyone to say "cheese" to get a smile usually fails to capture a convincing expression. Viewers somehow know when a facial expression is forced.

A photographer must be constantly on the lookout for happy people and ready to capture natural expressions as the action unfolds. With camera ready, walk around looking at active people. Check their expressions and snap the shutter at the peak moment. The happy person does not need to be the bride or the mother-in-

law, just someone having fun. A few happy people in a photo album is enough to imply the rest of the party goers all had a good time.

◻ Tender Moments

Closely related to romantic pictures are images of tender moments. Tender moments happen when people hug or touch each other. Never stage a tender moment; it will look phony.

◻ Humor

Humor can be seen and photographed at weddings. Humor is an important part of life and is vital to telling the wedding

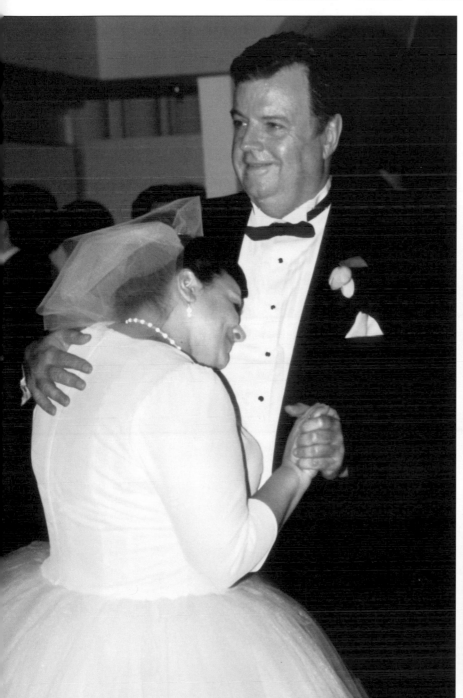

Left: What could be a more tender moment than this, the father-daughter dance. Photo by Suzanne Arndt.

Right: No prompting was necessary for this picture that defines the relationship between sisters. The photographer had known the girls for fifteen years and was their Girl Scout leader. When the bride spotted the photographer, she started choking her sister and made a funny face. Photo by Suzanne Arndt.

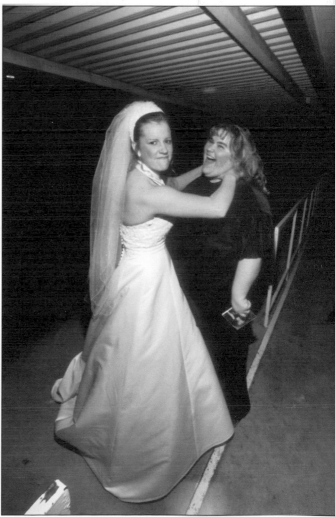

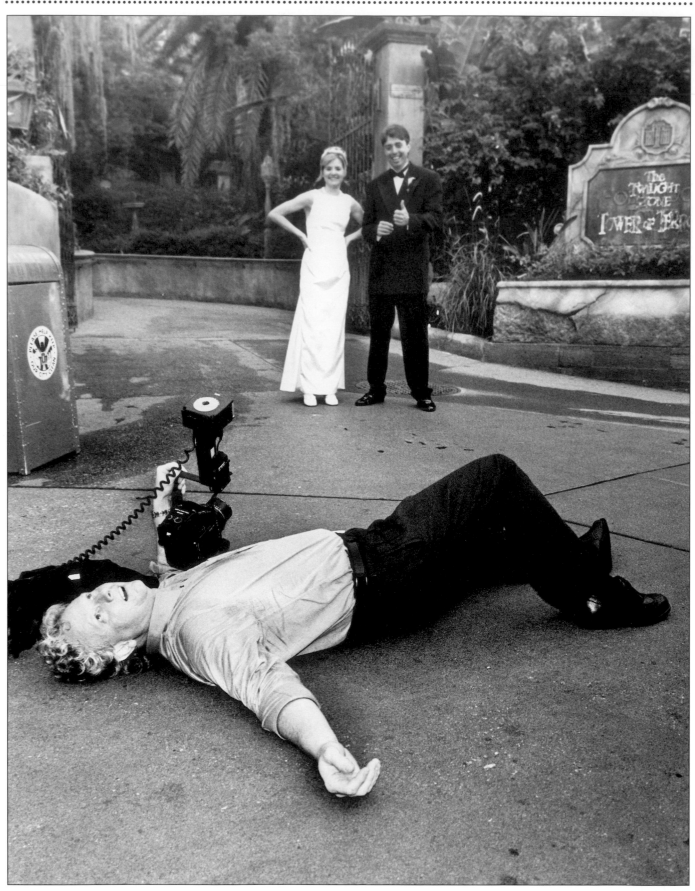

Wedding photojournalist John Unrue collapses in mock exhaustion before a bride and groom. The couple bought a copy of the picture because he is a part of their wedding story. Photo By Ricardo de Vengoechea.

"Shoot as many funny scenes as you find..."

story through photographs. Every wedding day has funny events; they are an outlet for the stresses of the day. Shoot as many funny scenes as you find, because the pictures make people remember happy times many years later.

Humor is one area where a wedding photographer may break the rule against posing pictures by staging the shot. Comedy is very difficult to pose. Suggest the subject do something that is funny and then photograph the result.

◻ Sequences

An interesting way of telling a portion of the wedding day story is to shoot a sequence. Sequences use several photos to show an episode during the wedding. They tell more complex stories than one picture alone. To keep the theme of the sequence clear, center on one person or activity.

Sequences change the pace of picture presentation in wedding albums. A sequence might consist of four 4"x6" prints on one page, or eight shots spread over two facing album pages. An entire storytelling album can work as a sequence, if the pictures are presented chronologically.

Picture placement and size selection create subtle overall impressions about the wedding day that are not necessarily obvious in the individual pictures. This, again, is called the third effect. In other words, the whole of the sequence is bigger than the sum of its parts. It is possible for picture selection to give a false impression of a wedding, so careful selection and sequencing is important when setting up an album. False impressions can result from omitting important people, places and events, or concentrating excessively on the bride (for example, including twenty pictures of her but only five shots of the groom). This erroneously implies that the groom is unimportant.

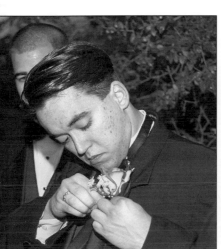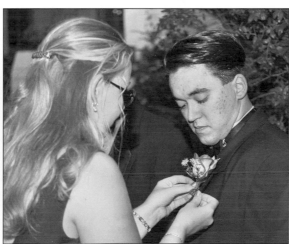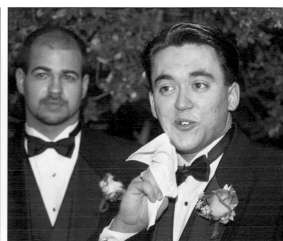

In this sequence of three pictures a groom struggles with a corsage, gets help and displays his relief by wiping his face with a handkerchief. Photos by Ken Wheatley.

9

THE
DETAILS

One part of photographing a wedding is creating images that help participants remember the event. An essential part is photographing the expensive little details that are indispensable to successful weddings and receptions. Attention to the tiny details helps set the look of the wedding and reception.

Details are where most of the wedding budget is spent. As one photographer said, if the father of the bride rented a tent for an outdoor reception and helped set it up, you better get a picture of the guests under the tent.

Photographs of details are displayed as small pictures in a wedding album. The following is a small sample of potential wedding details.

◘ Invitations
Arrange with the bride to get an invitation early. Besides guaranteeing that you have it in hand for a picture, it also reminds you of the wedding date, time and location.

◘ Rings
Formalist wedding photographers place great emphasis on displaying the wedding rings on the bride and groom's hands. Frequently, awkward pictures result. Formalists attempt to overcome the ugly shots by relying on strict formulas and rules. At professional photography competitions, pictures that fail to follow the rules lose points and prizes. Practitioners of the new styles of wedding photography have abandoned these tortuous shots and found new ways to shoot wedding rings.

◘ Cake
Often a photographer that is hurried or exhausted from trying to photograph too many weddings in one day will settle for an overall picture of the wedding cake. If the picture looks like a grab shot from the bakery's sample album, take a

"...find new ways to shoot wedding rings."

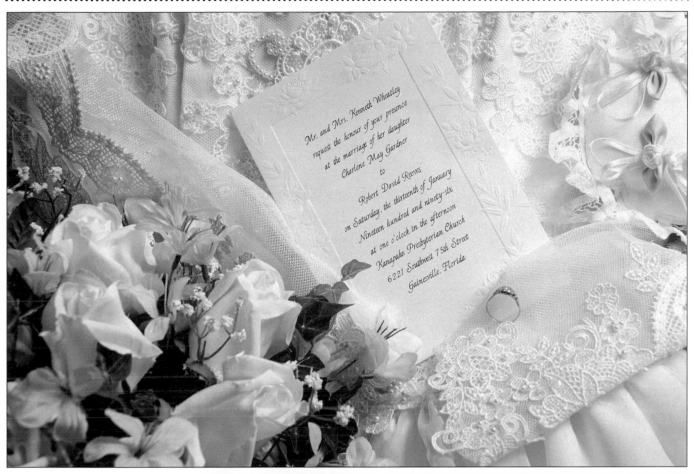

Mr. and Mrs. Kenneth Wheatley
request the honour of your presence
at the marriage of her daughter
Charlene May Gardner
to
Robert David Reeves
on Saturday, the thirteenth of January
Nineteen hundred and ninety-six
at one o'clock in the afternoon
Kanapaha Presbyterian Church
6221 Southwest 75th Street
Gainesville, Florida

Above: Photo by Janice Wheatley.

Right: This picture may have taken several minutes to create, but it did not disrupt other activities. The presence of flowers and ribbons makes the image soft and idyllic. Photo by Fran Reisner.

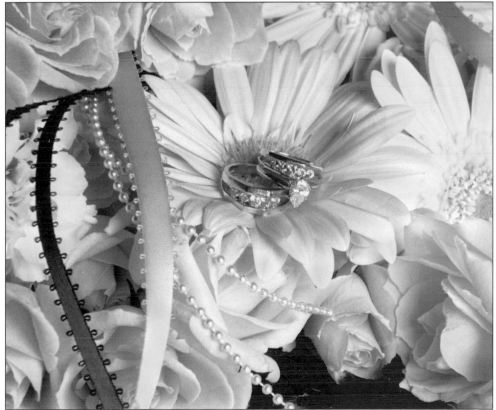

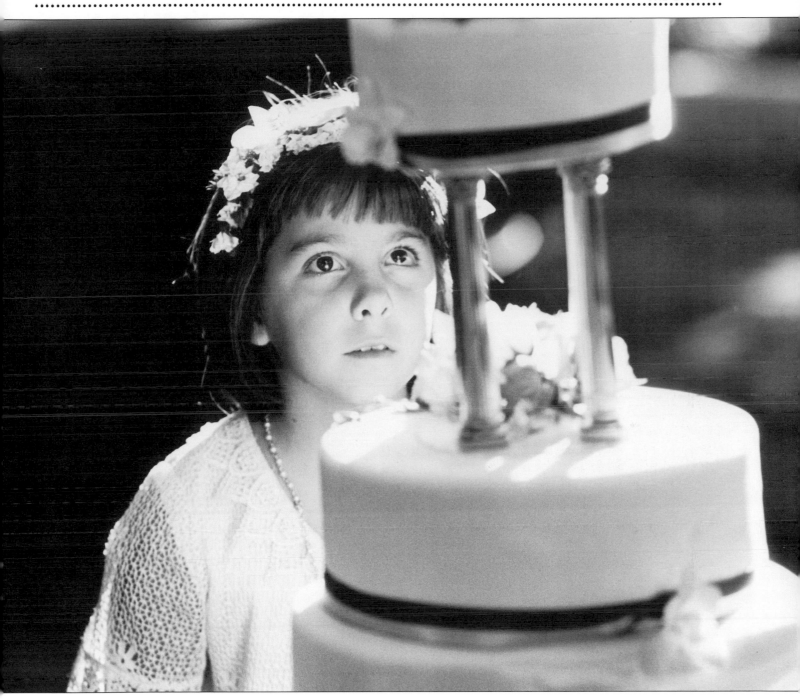

Above: Children and adults approach wedding cakes and try to figure a way of tasting the frosting before the reception. These pictures are memorable. Photo by John Unrue.

Opposite: A 17mm lens made this cake shot interesting. Photo by John Unrue.

second look at the cake. Consider moving in close to record some fine details of the decorations. Even better, photograph people's expressions as they inspect the cake – especially the reactions of children. If you are lucky, you can photograph a child trying to sneak a taste of the frosting.

◻ Flowers

Parents might spend thousands of dollars providing the wedding party with corsages and bouquets, as well as decorating the church and reception hall with flowers. Photographing the displays will help them remember the event years later. Capture the unique reactions of guests as they see the flowers.

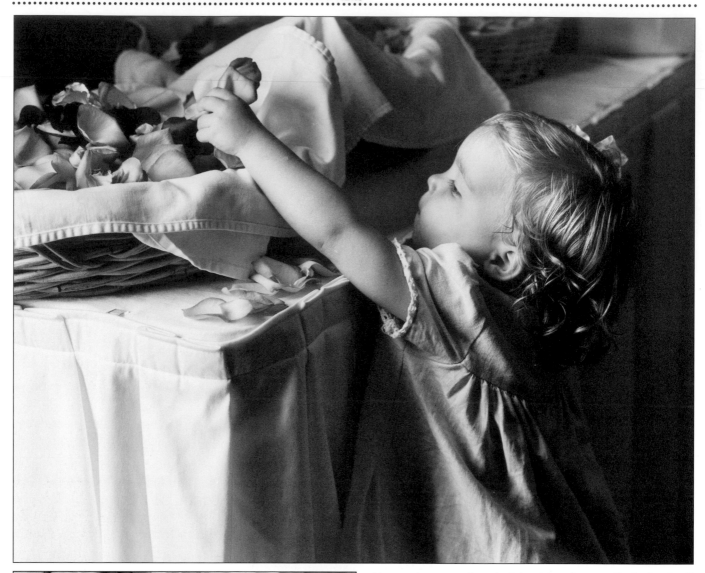

Above: A rare action shot involving flowers. Photo by Scott Livermore.

Left: The search for novelty in wedding photography results in some unexpected and exciting pictures like this one, where the shooter broke the rules by cropping out the heads of the flower girls. This contributed to the artistic impression of this wedding album. Photo by Scott Livermore.

◘ Music

Wedding and reception music have strong emotional content. Unfortunately, music is impossible to photograph. All a photographer can do is record its physical manifestations or create an impressionistic rendition of what music looks like.

◘ Food and Beverages

Like flowers, cakes, music and rings, food and beverages constitute a large portion of the wedding budget. Photographing the food and drink before they are consumed is a service to the bride and her family. These still life pictures are a challenge for

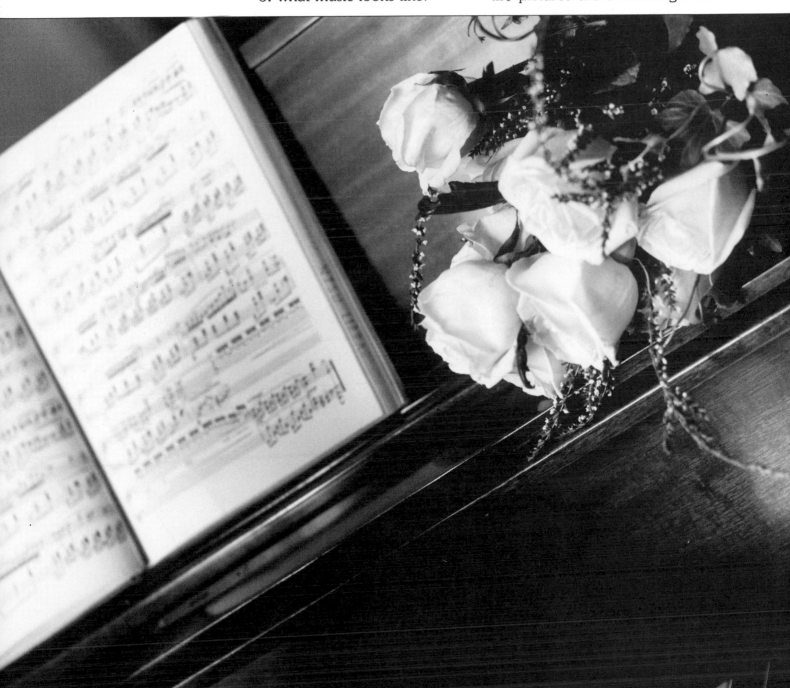

This Image of sheet music will remind everyone that someone played a piano on the wedding day. So would a picture of the pianist or the disc jockey. Photo by Scott Livermore.

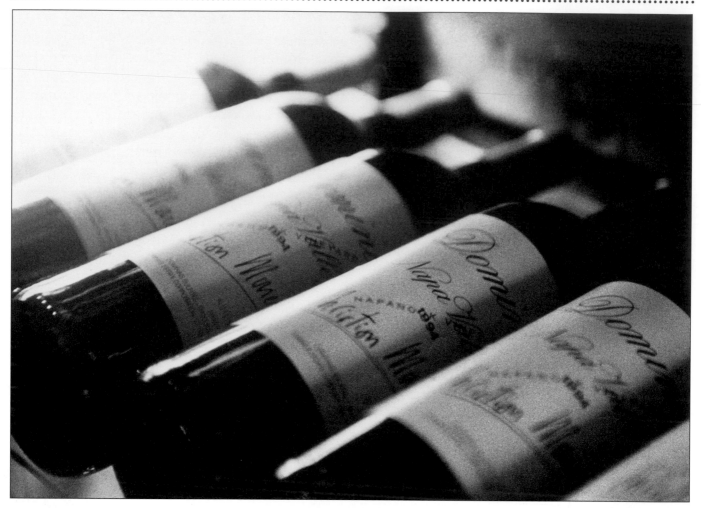

the creative photo-artist. To make these photographs do double-duty, provide free copies of these image to the caterers – it may result in some referrals and more wedding contracts.

◻ Place Settings

Like many elements, special care may be given to the place setting at a wedding reception. Guests may receive small reception favors to keep as souvenirs. Custom printed paper napkins with the couple's name and wedding date are commonly provided. If an item is important enough for the couple to have selected for their wedding, it is important enough to be photographed for their album.

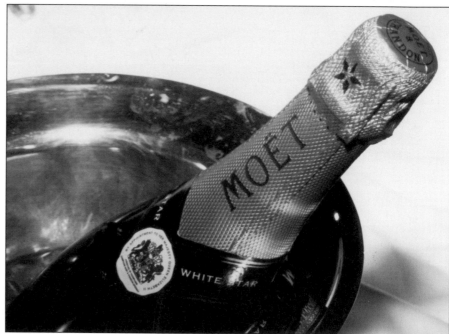

Top: The repeating pattern of these wine bottles makes a compelling composition and shows the care the wedding planners lavished on the event. Photo by David Jones.

Bottom: Champagne should be shot so that the label shows. The diagonal arrangement of this image enhances the composition. Photo by Suzanne Arndt.

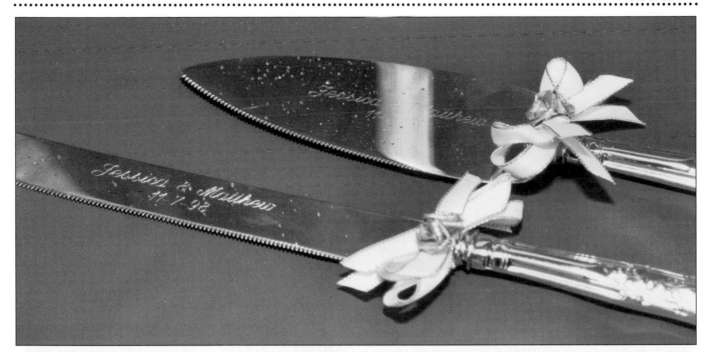

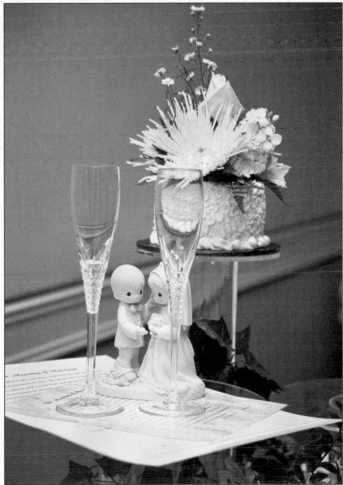

Top: Special commemorative knives and cake servers might be purchased and engraved. They become family heirlooms, just like photographs. Photo by Suzanne Arndt.

Right: These champagne flutes were purchased just for the bride and groom's toast. Photo by Janice Wheatley.

Left: Every wedding, it seems, has custom imprinted napkins. The text includes the couple's name and the date of the wedding. They end up in family scrapbooks. Photo by David Arndt.

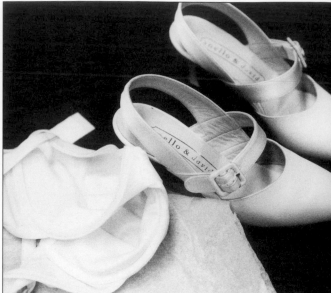

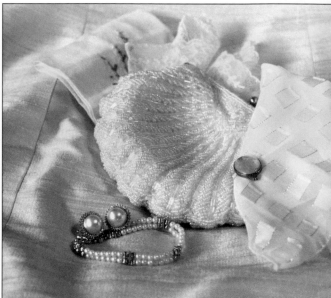

Left: Table decorations are another wedding detail that can be photographed. Photo by David Jones.

Top, Right: Shoes and underwear are important to the bride and therefore important to the sensitive photographer. Photo By Carol Andrews.

Bottom, Right: Jewelry and accessories are also important elements to record. Photo by Fran Reisner.

◻ Wedding Dress Elements

A big trend in wedding photography is close-up attention to the decorative elements of wedding dresses. Couture dresses are popular. Each designer incorporates elements unique to their studio. The dresses are becoming more interesting. Pay attention to the backside of the dress. Designers realize brides face the clergyperson during the ceremony. So, most guests see more of the back of the dress during the wedding than the front, which is why designers accentuate the back as much as the front.

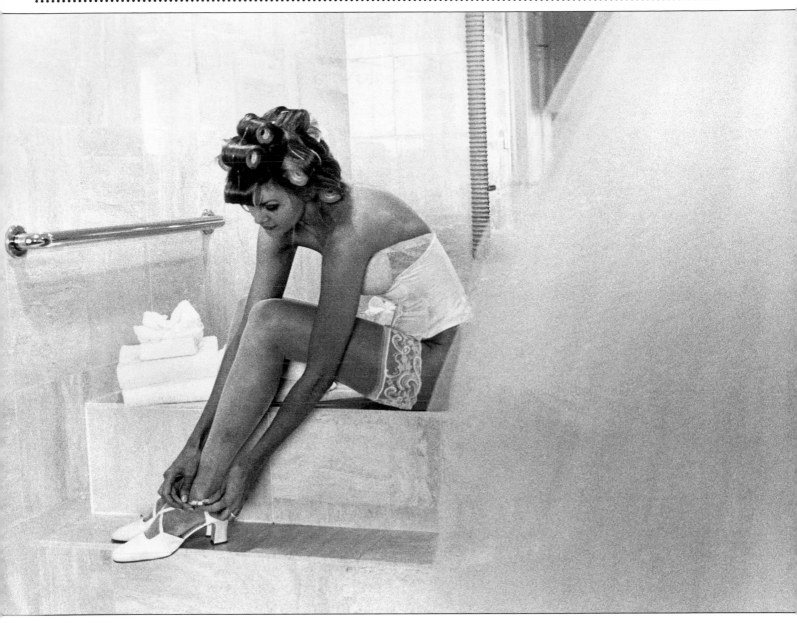

Usually, only women photographers are privileged to photograph the bride dressing for the wedding. This lady allowed John Unrue to pose this shot. The tulle from the wedding skirt is seen artfully placed, on the right. Photo by John Unrue.

❑ Preparations

An important portion of the wedding day story is the preparation for the ceremony and reception.

For some brides, having a male photographing her while getting dressed may present a problem. The photographer should reassure her that she will only be photographed when she is wearing more than she would at a beach or pool-side. The bride should also be reminded that she controls when the pictures will be snapped.

❑ Events to Photograph

Every bridal magazine lists the important events at a wedding and reception. These lists are meant to guide the bride while

she talks about which pictures she wants posed. The lists are also negotiating tools for use when working with a formalist photographer. The theory is that the fewer poses the bride contracts for, the less money she will spend.

For wedding storytellers, lists are less important because these photographers record everything. Storytellers price their work on a different basis than formalists. Pricing is discussed later in this book.

Previously in this book, the possibility of shooting 500 pictures on the wedding day was mentioned. That is not an outrageous figure – some photography teams report shooting up to 1,500.

A grandfather of the bride and his two daughters have fun while getting their hair done the morning of the granddaughter's wedding. Being silly for the camera relieves the jitters. Photo by David Arndt.

A child lifts the train during the procession to the outdoor wedding site. Including the bride in this picture would have changed the emphasis away from the girl to the woman. Photo by Janice Wheatley.

Photographers must play the numbers game. They need to photograph every activity from multiple angles and as many people as possible. Some photographers bring an assistant to keep cameras loaded and move the camera cases around. A big wedding might even need two photographers to cover everything and capture interesting activities. The worst thing that can happen is to miss something important.

Shooting lots of film is the way to play and win the numbers game. The more film shot, the higher the probability of recording a fine picture. It does not take many good pictures to fill a storytelling photo album. Sports

73

photographers regularly shoot hundred of pictures at football games to get one or two great action or feature photos for the next day's edition. Professional football games are timed to last exactly one hour. Wedding day activities might last twelve hours.

Wedding albums typically contain between 12 and 72 8"x10" prints. If 4"x6" pictures are also used, the final number of prints increases greatly. One of our clients filled her album with 144 4"x5" hand-made black and white pictures. But too many pictures might detract from the

Once again, creative cropping enhances a picture. A little mystery is added by cutting the photo off at the bride's waist; it makes the girls the focus of the image. Photo by Fran Reisner.

story if the photographers did not photograph enough different scenes.

◘ The Ceremony

The ceremony is the most difficult event of the day to capture. clergy and judges frequently place restrictions on photography during the ceremony. They want to prevent disruption of the sacred ceremony.

It is common for the clergy to ban flash photography. Others ban motor drives because they are noisy. Some will permit available light photography but tell the photographer to pick one place at the site and not move around.

Always comply with the wishes of the wedding official; it is a basic professional courtesy. If members of the audience start snapping off flash shots during the event, don't interpret their poor behavior as permission to follow suit. The guests are merely being inconsiderate.

There are several ways for photographers to work unobtrusive-

A 300mm ƒ2.8 lens allowed the photographers to get this shot without risk of disturbing the ceremony. Photo by John Unrue.

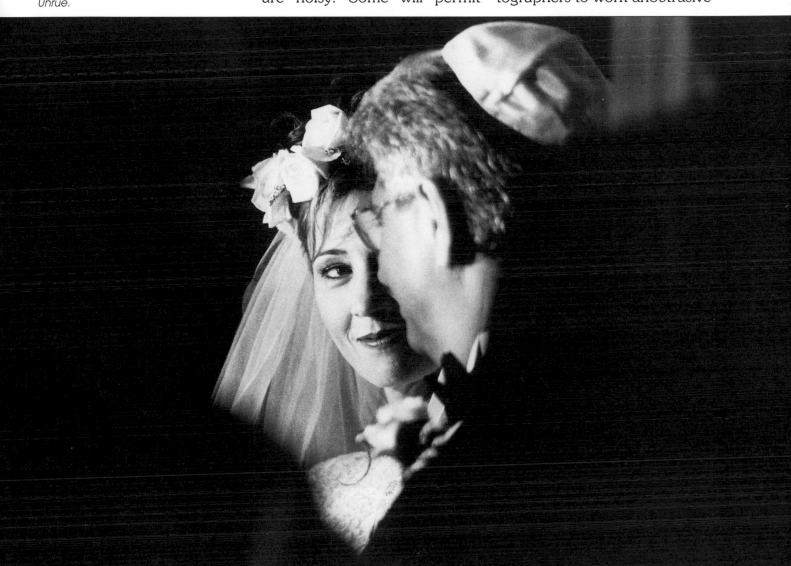

ly to capture images of the ceremony, if the couple and the minister agree:

- Multiple photographers can be positioned around the church to capture views from different angles. This eliminates walking around during the ceremony.
- Fast telephoto lenses such as 85mm ƒ1.8, 135mm ƒ2, 200mm ƒ2 and 300mm ƒ2.8 allow available light images to be taken at a greater distance from the ceremony. This solves the flash issue.

- Remotely triggered cameras can be placed in locations a photographer would never be permitted. A sound blimp can muffle the camera noise. (A sound blimp is a specially padded bag that fits over the camera to reduce its noise.)
- After the nuptials, position the couple and the wedding party in the same place they stood during the vows. The photographer can then shoot the scene with any combination of flashes and lenses.

The Wheatley's stood more than 30 feet from the ceremony and shot with a 300mm lens to capture this outdoor ceremony. The bushes framed the picture nicely. Photo by Ken Wheatley.

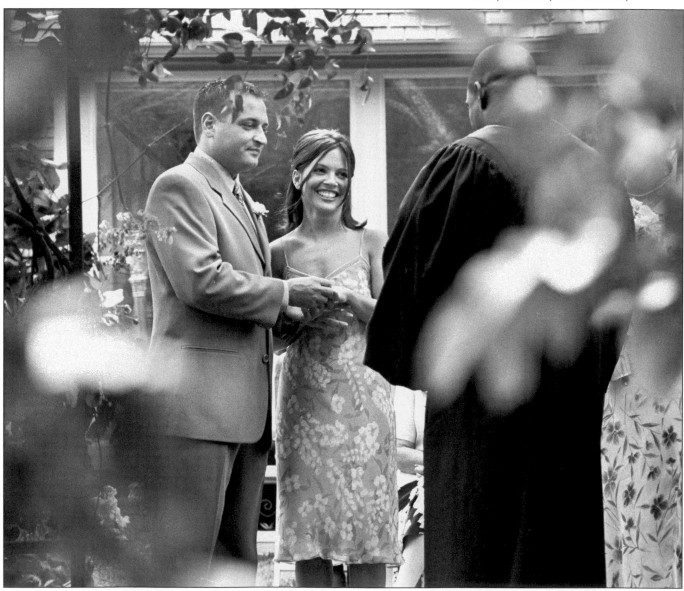

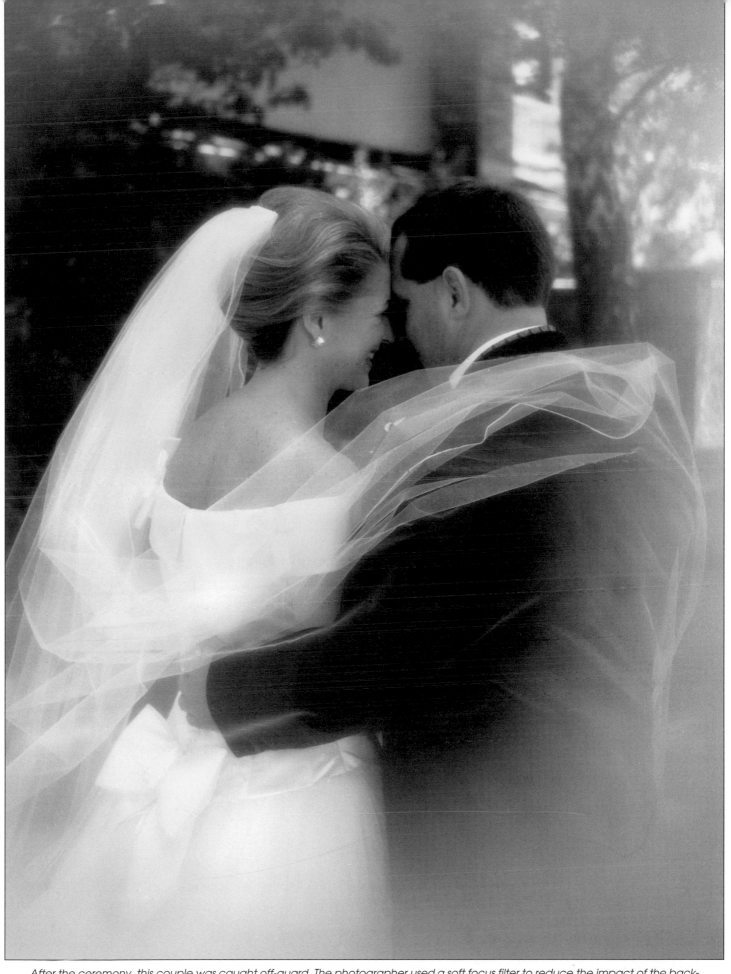

After the ceremony, this couple was caught off-guard. The photographer used a soft focus filter to reduce the impact of the back-ground. Photo by Fran Reisner.

◘ After the Ceremony

The time between the wedding and the reception provides opportunities for staging pictures that could not be taken earlier. Pictures that are posed at the church or temple altar are called altar returns. The formalists will use this time to photograph the various groups the client requested. It is also a good time to recreate the ceremony with the clergyperson and the couple. Photographers working in the new styles will use this time creatively to create unique images for the bride and groom's wedding album.

◘ Reception

A good reception is loud, noisy and filled with happy, active people who often do funny things. Receptions, therefore, are photographic gold mines.

The formalist style photographer will focus mainly on the required reception events, including toasts, first dances, the bouquet toss, the garter toss, cake cutting and novelty dances, to name a few. Creative photographers will also shoot these events, but then keep looking for unique or unexpected opportunities.

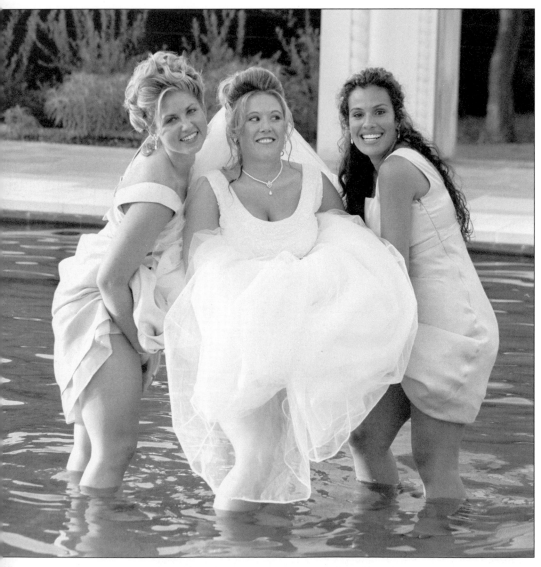

August weddings in Texas are hot. Temperatures regularly top 100 degrees Fahrenheit. After the wedding, Ken spotted the bride looking at the water in a fountain and encouraged her to climb in. Photo by Ken Wheatley.

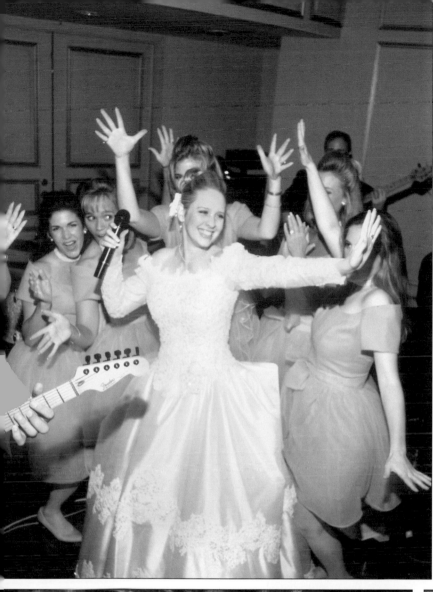

Top, Left: A bride and her friends have a wonderful time singing and dancing at a reception. The guitar neck tells us that music is being played. Without the guitar the picture might not make sense. Photo by David Jones.

Bottom, Left: Women cluster around the now unavailable groom. Note the bridal portrait in the background. Photo by David Jones.

Bottom, Right: Most people are not capable of posing and looking natural, so the results are often stiff and awkward. However, wonderful pictures like this can be captured without posing. Photo by Suzanne Arndt.

◻ Concluding Wedding Day Coverage

All good things must come to an end – even wedding day photo coverage. Search for a concluding image to complete the photo album. Some albums leave off with the bride and groom leaving the church while dodging rice or rose petals. Some photographers like to finish the album with the happy couple entering the automobile. You might even want to stay around to shoot the clean-up (see page 95 for an example).

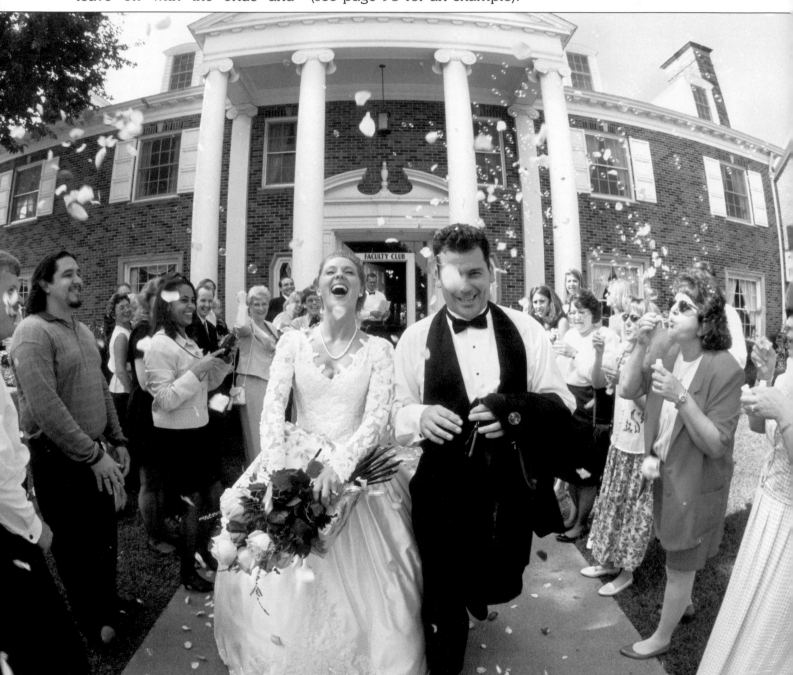

A reception hall at Southern Methodist University is the location for this concluding image which was was shot with a 14mm fisheye lens. Photo by Scott Livermore.

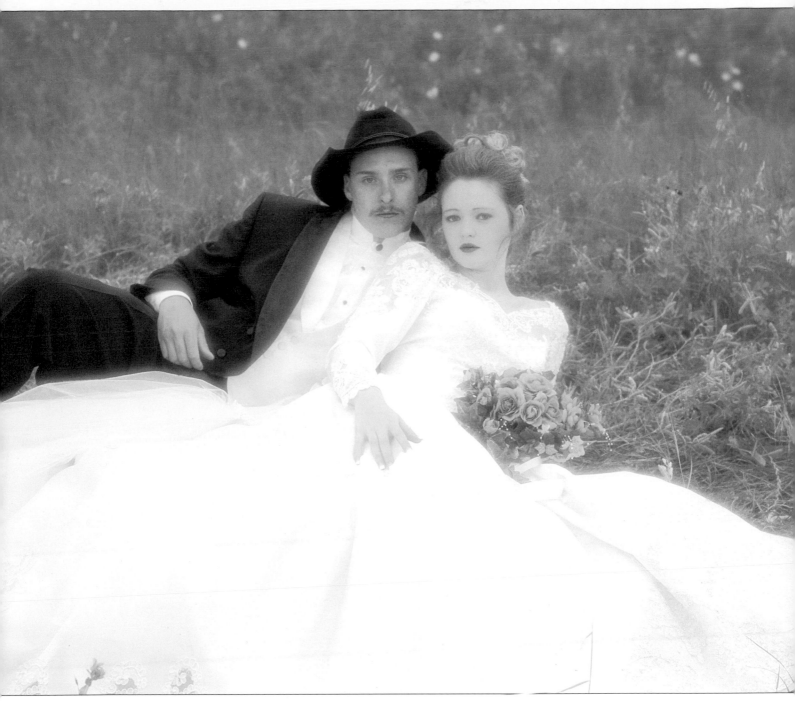

Including the groom in the bridal portrait is still a little rare, because many brides believe it is bad luck for the groom to see the wedding gown before the ceremony. Photo by Janice Wheatley.

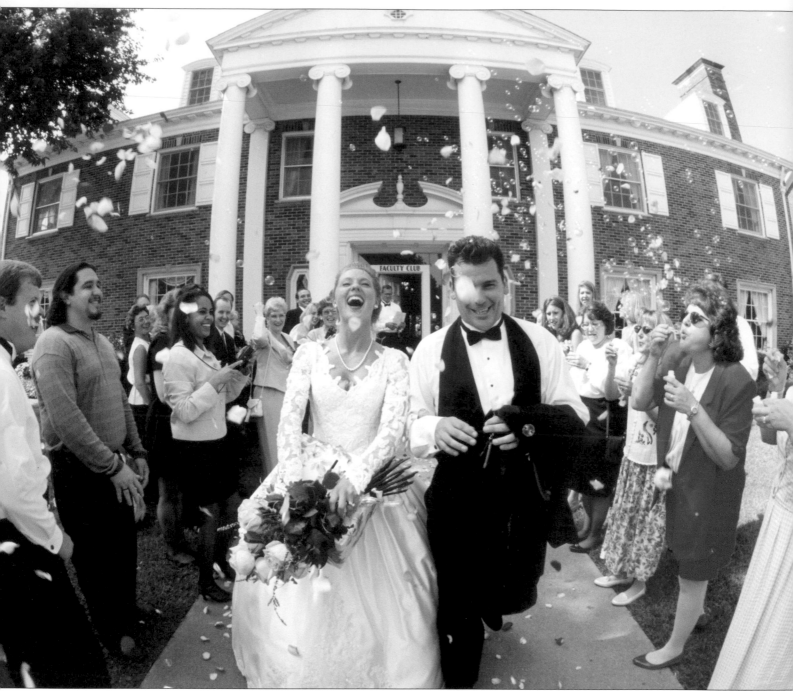

Above: A reception hall at Southern Methodist University is the location for this concluding image which was was shot with a 14mm fisheye lens. Photo by Scott Livermore. For more on this topic, see page 80.

Right: Creative cropping enhances this picture of two little girls at a wedding. A little mystery is added by cutting the photo off at the bride's waist; it makes the girls the focus of the image. Photo by Fran Reisner. For other ideas on subjects and events to photograph at a wedding, see page 71.

Opposite: A 14mm lens was used to capture this groom and his grooms-men. The bride suggested this image. Notice how the relative size of each person is exaggerated and the normally straight parts of the play equipment are curved by the fisheye lens. Photo by Ken Wheatley. For more on using wide-angle lenses in wedding photography, see page 15.

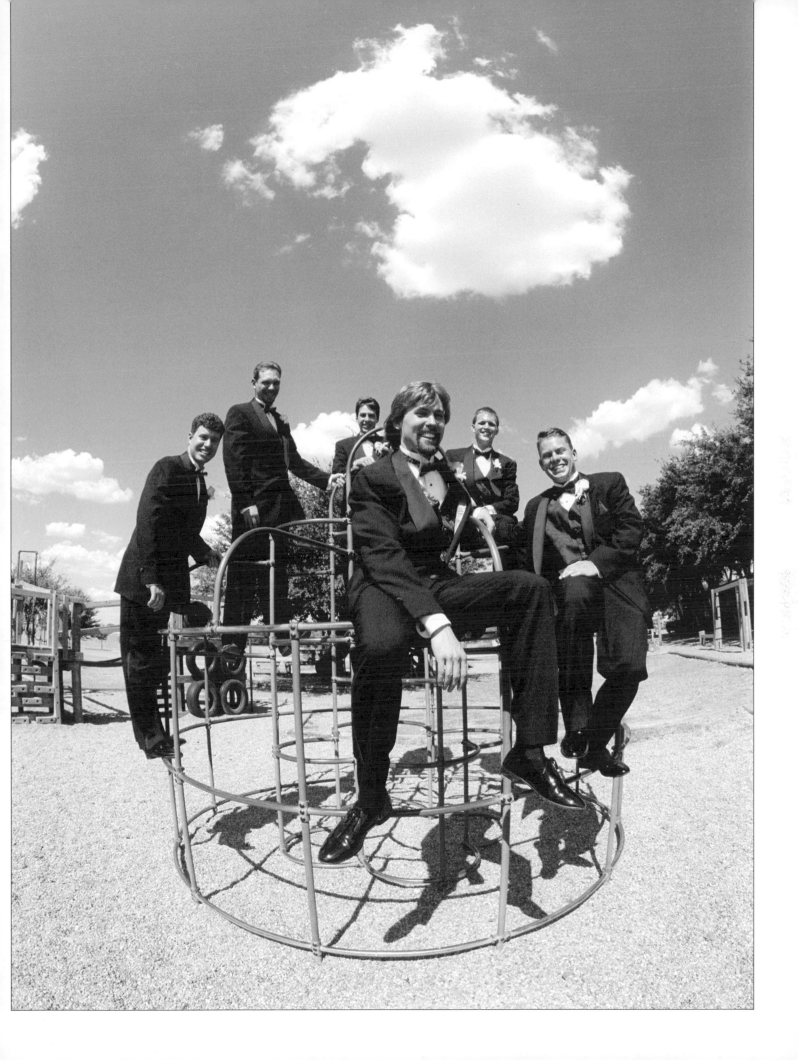

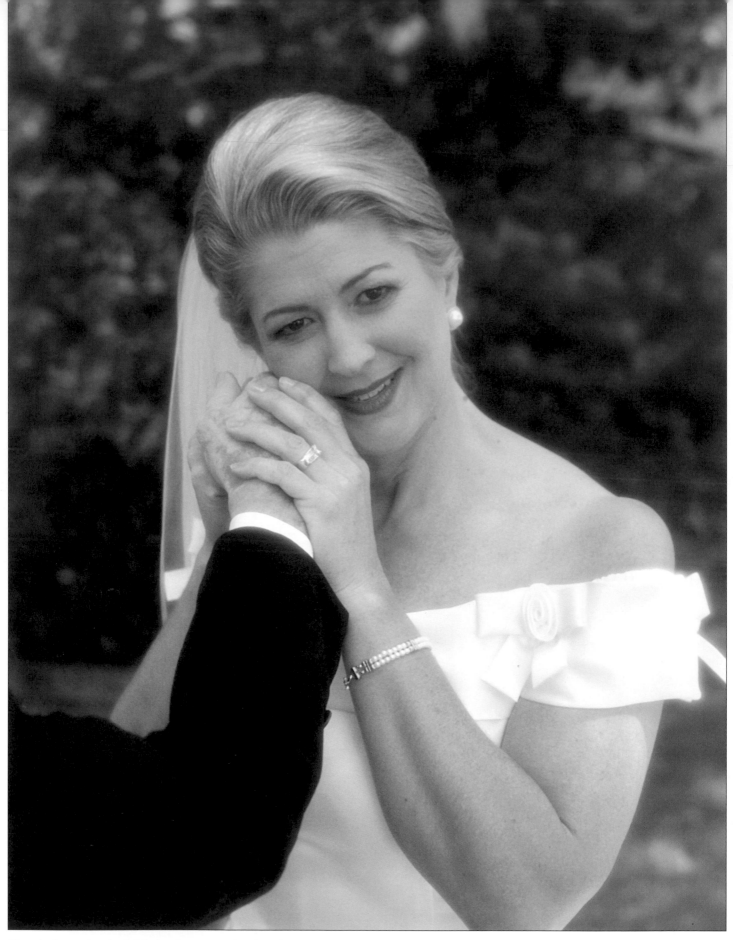

The photographer took this simple approach when she saw the bride touch her husband's hand to her cheek. The result shows the bride's emotions. Photo By Fran Reisner. For more on this romantic approach to wedding photography, see page 55.

10

ADVICE FROM TOP WEDDING PHOTOGRAPHERS

◻ Carol Andrews (Houston, Texas)

"I am an artistic person. I am not a technical person ... so I break a lot of rules," Carol Andrews of Houston says. Andrews is a nationally recognized photographer specializing in bridal portraiture. Her pictures have been exhibited at the Photokina photography trade show in Cologne, Germany, EPCOT Center at Disney World in Orlando, Florida, The Sherman Hines Museum in Nova Scotia, Canada and at the Paraiso Gallery. They were also featured in the Professional Photographers Of American International Masters Loan print collection. Andrews teaches bridal portraiture nationally and is a consultant to the Polaroid corporation.

"I enjoy expressing beauty and my love for life through a camera, and sharing the images and stories with others. The camera and film are my medium. My portraits evoke a feeling, char-

"Architecture is a vital tool for many of Andrews' bridal portraits."

acter, and the very spirit of the person or persons portrayed. It should be more than a standard cheesy grin at the camera," she says.

"Women are socialized about being a bride throughout their childhood. So they have a view of the wedding as reality and as fantasy. It is important to fulfill the fantasy. The size 22 bride is just as happy as a size two bride," she says.

Andrews likes softly focused images and "grain as big as baseballs." As a result, her images have a consistently romantic aura. Some appear as if a fog bank had rolled in from the Gulf Coast, other photographs are sharp as a tack but imply meaning and emotion through place and posing.

Architecture is a vital tool for many of Andrews' bridal portraits. The place where a marriage is performed is an important element to record

81

and preserve in wedding photographs. She will locate an interesting architectural feature and place the bride with the element in an appropriate pose. The bride might occupy less than a quarter of the image. Andrews selects architectural sites that provide a monochromatic color range because limited color is attractive and helps focus attention on the bride.

"[Brides] want to look like they came out of a magazine. They are strongly influenced by the media. But you can't do this with every bride," Andrews says of her clients.

Andrews must satisfy two clients at each wedding. "We have to meet the expectations of two generations. Mom likes the portrait in a gold frame mounted on canvas, but the bride wants fine art and black and white photos. So, we have different products for different age groups. We tailor our products and sales presentation to the desires of each age group. We do a lot of mother-daughter portraits."

◻ Jule Bovis
(Richardson, Texas)
Jule Bovis is a highly respected photographer with more than 35 years experience photographing weddings. Bovis has photographed many famous and powerful individuals in Hollywood, and clients have flown him to Disney World, Hawaii, San Diego and the Colorado ski resorts. His studio is north of Dallas in Richardson, Texas.

"I don't see everyone wanting the photojournalism style. How do you get the groups? If you don't get the group pictures, then they are going to say 'I am so disappointed.' I still like the classic approach to wedding photography…but I try to incorporate both the classic style and some of the new styles," Bovis says. "Working to find new techniques, memorable backgrounds and interesting posing takes the monotony out of the work."

Bovis looks to photograph spontaneous moments to keep his pictures fresh. For example, at a wedding in 1998 he decided to photograph some dancers using electronic flash and a one second shutter speed. The result was a picture that was both sharp and blurred. He successfully employed both methods of showing motion in one shot.

"People hate dark backgrounds," Bovis says. To avoid the black background, Bovis has an assistant keep a second portable flash aimed at the background. The second flash is triggered by a tiny radio transmitter. Both flash units are set to produce the same exposure level.

◻ Scott Livermore
(Irving, Texas)
Scott Livermore emphasizes in his advertising that he is a wed-

"I still like the classic approach to wedding photography…"

ding photojournalist. "Our goal as photojournalists is to blend in with the guests and capture the moments as they happen."

"A bride once told me, while looking at the proofs, 'Scott, I don't know how you got all the pictures of the reception because I don't remember you being there.' That's high praise," he says with a smile on his face. "I look to capture the kind of moment that just happens."

Few weddings can be shot entirely in the photojournalistic style. Members of the wedding party want to be photographed together. Big groupings of people do not occur spontaneously in a way that allows every face to be seen, so Livermore will direct the subjects into interesting formations. "The more you tell some people to stand still and pose, the more you stiffen them. So I just pose them casually. I don't mess with veils, the train and hand positions. For example, when the bride and groom come together at the reception, I'll say to them 'How about a kiss?' They kiss, boom, I made my shot. Casually posed pictures for family and friends is what we call them," says Livermore.

Livermore has been photographing weddings since 1994. He adopted the photojournalistic approach in 1995. He has photographed as many as 45 weddings in a twelve month period. "That is too much. I am

> "'That's high praise,' he says with a smile on his face."

going to cut back to half or two thirds of that. Enjoying the work is the number one thing. You don't have to go to work a day in your life if you enjoy what you do." Livermore says.

☐ John Unrue
(Winter Park, Florida)

Unrue, along with several friends founded the International Wedding Photojournalists Association to promote the application of the photojournalism style to wedding photography.

"There are about a dozen of us around the country now," Unrue says. In addition to promoting photojournalism, they make referrals to each other when they are booked.

Admission to International Wedding Photojournalists is accomplished by submitting a portfolio of wedding pictures made in the photojournalism style. The phone number and address for the association is listed in the appendix of this book

"I started shooting in the photojournalism style about seven or eight years ago [1990 or 1991] because I was fed up with the standard, 'stand 'em up, line 'em up, shoot 'em' kind of wedding photography. Without telling anyone, I started shooting the weddings like I would shoot a basketball game or the war in Bosnia. The clients loved it and actually ordered more prints," he says.

The Business of Wedding Photography

ATTRACTING CLIENTS

"... be sure to have large, clear and attractive signs..."

◻ Retail Location vs. Home Business

Drive-by traffic is a vital concern for the photographer operating a retail location. As a general rule, it is wise to choose the location with the highest automobile traffic that is consistent with your budget. However, there are some exceptions. If the studio is hard to reach because of the high traffic, then traffic is a liability to be avoided. High levels of foot traffic, such as that generated by customers inside a major shopping mall, is a positive factor. To take advantage of these expensive, high traffic areas, be sure to have large, clear and attractive signs so the people know what your business does.

Retail locations have high operating expenses that must be met every month. The wedding business is seasonal (busy in spring and summer, slow in winter). If you don't have enough cash left over from the busy period to tide you through the slow period, your business is more likely to fail. To counter the high costs of a retail location, most studios also photograph seniors, families and product photography.

Home businesses, on the other hand, have fairly low overhead. If a home business is slow, it is easier to cut operating expenses and survive. This is especially true for the thousands of part-time photographers.

◻ Websites

To attract couples to a home business, it is important to develop a large network of friends and former clients willing to refer their friends to you. An alternate method is to have an active and effective advertising program.

For business in both retail and home locations, websites are an effective method of making contacts that lead to sales. Web pages are a big hit with wedding photographers. "You

have to get your images before the people. Websites make your business accessible 24 hours a day, seven days a week." Carol Andrews says. She details her packages, services and prices on her webpage <http://www.andrewsphoto.com.> Publishing the packages and prices on the web page pre-qualifies the buyer. The bride whose budget does not match Andrew's prices does not take up her staff's time. "I do not want the $800 wedding," Andrews says.

Effective websites include many meta-tags. Meta-tags are bits of programming that tell internet search engines what is on a site. The more meta-tags the better. A wedding photographer's site may include meta-tags for wedding photography, marriage, snapshots, pictures and other relevant terms.

It is also important to include your phone number, address and a button that starts the user's e-mail program so they can sent you a message.

Many of the local guilds associated with the Professional Photographers Association of America host websites for their members. Check with professional organizations you belong to and ask whether they provide this service.

◻ **Bridal Fairs**
In many communities, businesses and promoters hold bridal fairs. These are trade shows for

potential brides. Brides and friends get to see a variety of wedding merchandise in one place. This saves them the trouble of driving around town for days before making their decision. Some bridal fairs attract 5,000 visitors.

Bridal fair promoters charge photographers for renting space at the fair. Photographers display their pictures, albums and other products. They talk to potential clients about photography and sometimes get them to sign photography contracts.

◻ **Bridal Magazines**
Bridal magazines are a good way to expose potential clients to your work. The advertising department at the magazine can also help design an effective advertisement for you. When shopping for a publication to advertise in, keep in mind that the bigger the circulation of the magazine, the higher the advertising rates.

You can compare magazine ad rates (to get an objective sense of what you're getting for your dollar) by dividing the cost of the ad by the number of readers (rounded to the thousands). This gives the cost per thousand readers. For example, if a 1/4 page ad in a magazine with 10,000 readers every month charges $137 for the ad, then the cost of the ad is $13.70 per thousand. If a competing magazine has 8,500 readers and charges $85, for the same size

"... the magazine can also help design an effective advertisement..."

ad, then the cost is only $10 per thousand.

The only catch is that you must also take into account the type of reader that magazine attracts. Your ad might work in one publication, but not in another if you are reaching different audiences. For example, if you charge a minimum of $3,000 for a wedding but the readers are looking for a $995 wedding, you are advertising in the wrong place. Your ad won't be effective with these readers.

A good ad should result in several photography contracts per month. Yet, no matter how many telephone calls an ad might generate each day, the photographer must still convince the client to see the pictures, then sign the wedding photography contract and put down a significant deposit on the services.

◻ Postcards

Glossy color postcards are popular with many wedding photographers. These attractive advertising tools display a photographer's pictures in an very attractive way and includes a sales message on the front, along with the photographer's name, phone, address and website. The flip side of the post card can be custom printed or contain a hand written message.

Scott Livermore boldly displays the price of his minimum package on his cards. "Putting the

minimum price on the card prequalifies the bride. If they can't afford the package, they don't call. They don't waste my time or their time. I started doing this because I hear brides complain that photographers won't quote prices over the phone. The photographer wants the opportunity to show their work and make the sale before talking about the price. This makes some brides angry."

◻ Newspaper Advertising

Newspaper advertising works well in some markets, and not so well in others. If other studios advertise in newspapers, it's a good indication that newspaper advertising works in your area. Absence of wedding photography ads tell you to avoid newspaper advertising.

◻ Display Advertising

Some wedding industry merchants allow photographers to display wall prints, sample albums or just business cards at their stores. Ask the owner for permission and see what happens. Some merchants rent the space, others have exclusive deals with photographers. Each business is different. Merchants that might cooperate include banks, banquet halls, bridal shops, caterers, churches, florists, hotels, travel agents, tuxedo rentals and wedding consultants.

> "A good ad should result in several photography contracts per month."

12

How to Sell the New Styles

◻ Selling Points

Regardless of a your skill, outstanding creativity and vast experience, the ability to sell yourself and your services to a stranger is the single most important element that determines if you are successful or just another starving artist. Couples rarely know the photographer they hire. They must make their decision on a number of factors, including price, the package size and the appearance of the sample pictures. The most important factor is often the relationship that is created between the couple and the photographer during the sales presentation.

Developing a rapport with the client is mostly a matter of listening attentively to their statements and requests, as well as discovering their hidden desires. Listening and agreeing with them when possible is the key skill. Be slow to disagree with them, thereby avoiding conflict. Sometimes it is appropriate to

direct them toward your desired goal by asking them leading questions. The questions should be phrased so there is only one acceptable answer: yes. For example, "Don't you think this pose shows off the bouquet?"

Some brides and their mothers have not yet been exposed to the new wedding styles. "Frequently you have to educate a client about the new wedding styles because there are very few of us in the country overall that can call themselves wedding photojournalists," Scott Livermore says.

It is therefore important to discuss the unique features of your images, especially if they are not traditional. Inform the client of the range of pictures you generally shoot and how many are typically used in the album to tell the story of the wedding day. Show examples which illustrate how the new styles create more exciting and unique pictures, and explain why the

"... discuss the unique features of your images..."

"... music, light, texture and fragrance support the sales presentation."

new styles also result in a pleasant, less stressful, wedding for the client. Explain the idea of storytelling, and show the client your skills at creating a storytelling album.

Conclude by saying that your high level of photographic skills command a premium price, then ask for the sale.

◻ Merchandising

"Merchandising our product is so very important," says Carol Andrews. Her studio is located in the Houston arts district. She uses music, light, texture and fragrance to support the sales presentation. "I want impact from all the senses," she says. The decor of her studio follows interior design trends, which are important to upscale clients.

"When the bride comes in to pick up her pictures, I want at least one of them framed and on display so she can see it the moment she walks into my studio," Andrews says. The displayed picture then becomes an impulse purchase for the clients. The photographer merely has to ask if they want the beautiful picture. Few people resist. If they decline, then Andrews has a fresh display print to use.

A well-merchandised studio displays premium wedding albums imprinted with names and dates on the cover. A wide variety of portfolio boxes, tasteful frames in expensive looking gold and silver, and mats displaying sample pictures are also arranged in small groupings with accessories. The groupings, each in a different decor, suggest ideas to clients, so the salesperson does not always have to make the suggestion.

◻ Picture Proofs

Paper-based proofs are an expensive and not particularly effective method of showing clients the pictures. Clients always want to take them home and study them before making up their mind. They do this out of fear of making an expensive mistake. Unfortunately, some clients take six months to decide, others never decide.

Paper proofs have to be put in special-order albums and then circulated to each set of parents, grandparents and members of the wedding party. At the very best, the process takes weeks. At the worst, the couple divorces before they place their print order.

Photographers who don't collect their entire fee before the wedding must wait for the proof book to be returned before realizing a profit.

As a result, many studios are adopting some of the following proofless sales techniques.

◻ Video Tape Proofs

Scott Livermore is proof-less. He delivers the images to brides and parents via inexpensive video tapes. "With paper proofs if I shoot 500 pictures that costs

89

me about $500. So I transfer all the pictures directly from the negatives to video tapes," he says. Showing proofs on a video tape is much less expensive. Tapes can be duplicated for a few dollars each. It is also very difficult to make pirate prints from a videotaped image.

Using videotapes also means that Livermore can afford to provide everybody with a copy, so they can order directly on his toll free number. "It is good to strike while the urge to buy is hot. Plus it takes all the pressure off the couple to distribute the proof book." Since switching over to video cassettes, his print sales have climbed and his profits have soared.

Livermore purchased a Tamron Photovix and some basic video editing tools so he can create the tapes himself. He uses the Photovix to photograph each negative. The image is converted to a color-corrected positive and cropped. He places an order number over the picture and then saves each image on about four seconds of tape. All 500 images take up about ten to fifteen minutes of tape.

Short blank video tapes are available from suppliers nationwide. Bulk purchases receive heavy discounts. Custom labels can also be printed from any home computer using Avery Dennison or similar label-making software.

◻ Transview Slides

Transview slides are slides made from the original negatives at the time the film is processed. No paper proofs need be made. They are used to show clients the best pictures, which eliminates the weeks-long process of showing a proof book to every member of the wedding party. This is the method Carol Andrews uses. One approach is to show the slides in an interesting sequence with music in the background.

◻ Websites

Photographers nationwide use websites to display proofs for clients that are "plugged in." Dozens of small color pictures are posted along with an identifying number. The client phones in the order and the project is completed. Some of these photographers restrict viewing to the client alone by requiring secret passwords to enter that area of the site.

Scott Livermore uses his website at <http://www.scottlivermore.com> to sell prints to people that do not get to see his video proofs. He places several of the best pictures from each wedding on-line for viewing and takes orders over the telephone. Unlike some photographers, he does not restrict access to the portfolios. Instead, he refers potential out-of-town clients to the website so they can see his work, using the site as a portfolio for his wedding photography service.

"... show the slides in an interesting sequence with music..."

13

PRICING YOUR WORK

· ·

"... achieve a balanced pricing plan."

The most difficult thing for beginning wedding photographers to achieve is a balanced pricing plan. Greed may push the asking price sky-high, or inexperience in calculating actual overhead may leave no profit. Ultimately, a photographer must solve the pricing dilemma in a way that attracts the highest paying customers that her photographic talents will support.

People who are willing to pay $10,000 for photography seek out nationally famous photographers. These top professionals have been written about in national bridal magazines or have written and illustrated stories for the magazines. Often, they write photography books and lecture at photography conventions.

The $500 assignment goes to beginners that are friends of the family. The money pays for processing and an album. That family will be delighted with any

pictures the photographer produces and not very surprised if the pictures don't look professional.

Photographers with a couple of years of full time experience should consistently win assignments in the $1,000 to $3,000 range. In this range, processing expenses and album selection influence how many pictures are promised and how many hours a photographer will commit to on a given Saturday. A few physically strong photographers can complete three weddings on Saturdays. Two weddings is a more common goal.

◻ **The Criteria**

Brides choose what products and services they will buy in three different ways. They select the album size, choose among pre-priced packages and decide on *à la carte* services.

Photographers that package by album size commit to doing whatever it takes to fill the

album with pictures. Albums might contain 6, 12, 18, or 24 pages. The price of the album itself may vary from $30 to $300, so this is a factor to be carefully considered in pricing.

The most common method is to offer between three and five product packages. These can be very complex and confusing for both client and photographer. Packages make it extremely difficult for the client to compare prices between photographers, because the products inside each package are different.

The *à la carte* method gives the bride and groom the most control over their budget. They must choose how many hours of the photographer's time they want to pay for, which album they want their photos in, and the exact number and size of pictures.

Pricing to match the competition is a time-honored and effective practice. You may find it helpful to gather a few dozen brochures from other photographers, analyze the products and base your offerings on their packages and pricing.

Another way to determine how to price photographic services is to decide how much money a Saturday of work is worth, then add the actual costs of the assignment to the price you quote. For example if you value Saturday at $1,000 and shooting ten rolls of film costs $365 then charge $1,365 plus sales tax. This process makes it easy to establish packages at several different price points. The only variable is the amount of film you will shoot and the price of the album you will provide.

"This process makes it easy to establish packages..."

Packaging Your Work

14

BUILDING THE WEDDING ALBUM

The final product, the goal of all this photographic work, is the wedding album. Since the formalist sees weddings as portraiture, the sequence of the pictures in the album is of little importance. The photojournalist, on the other hand, is a storyteller. Stories have plot lines, a step-by-step sequence of events that, when assembled correctly, tells a logical, understandable narrative.

The size and depth of the story that can be told is influenced by the wedding photography budget. The more money spent, the bigger the album. A big album holds more pictures and so tells the wedding story in greater detail.

A simple wedding story starts at the beginning of the day and flows, event by event, to the end. It is seemingly a very simple plot, but weddings can actually be very complex with multiple events happening at the same time. Fortunately, it is not always necessary to follow a rigid time line. There are several techniques that can solve this problem.

First, dispense with the idea that the best album is made entirely of 8"x10" prints. This is too limiting. It restricts the number of pictures that can be included. Storytelling albums can use any size and shape picture. Photographer Michael J. Ayers includes pop-up pages like in a children's storybook. He uses three-part fold out pages for panoramas and even L-shaped pages from 24"x24" inch prints of a bride and her long train. To achieve these special designs, he works closely with the company from which he buys the physical albums to create special album pages.

Mixing 8"x10"s, 5"x7"s, and 4"x5"s in one album is easy. It is the photographic equivalent of a writer creating different length chapters in a novel.

"... includes pop up pages like in a children's storybook."

Important parts of a story get more words for more detail. Photographically, big pictures are reserved for big parts of the narrative. Small pictures are for small bits.

Use the third effect (discussed in Chapter 2), to show emotions and events that are not easily captured in one image. One photographer placed a shot of the groom making a toast on one page of the album and a similar shot of the bride on the facing page. The couple were photographed so that in the album they were facing each other. This creative concept is a welcome relief from the traditional format of the couple drinking a toast with intertwined arms – an awkward position.

A montage of unrelated dancing pictures can use the third effect to tell the reception dance story. Sequences of pictures can display an activity such as the bride dressing before the wedding or the bride struggling to enter the car.

Staying late allowed the photographer to catch a shot of an employee cleaning up after the reception – a possible concluding image for the album. Photo by Scott Livermore.

The problem of displaying two events which happened at the same time can be solved by using album pages that accept four pictures per page. Place one event in the top row across two facing pages and the other in the bottom row.

It is important to have an establishing shot and an ending shot. The establishing shot is an overview of where the pictures were made. Exterior images of the bride's house, groom's house, church and hotel are excellent for establishing the location. Concluding shots are similar in nature. Typically, they show the last activity at a location. A strong concluding shot could be the couple leaving the reception or boarding an airplane.

Keeping all the storytelling decisions straight and getting them communicated to the person assembling the album can be difficult. Art Leather, a premium album company, offers software that simplifies the process. The Art Leather software is called Montage. As with a publishing program, the user lays out the picture sequence and cropping on the monitor and then prints out paper proofs to show the couple. This allows them to order any changes or picture substitutions before the album is permanently assembled. This software can help eliminate long waits while the couple decides which pictures to put in the album. The software also prints the directions for Art Leather and an invoice for the photographer.

"This software can help eliminate long waits..."

Staying after the wedding allowed Suzanne to capture this image of the father of the bride vacuuming the church reception hall. Photo by Suzanne Arndt.

15

PRODUCTS FOR WEDDING PHOTOGRAPHERS

∙∙

□ **Boxed Art Print Portfolios**

A hot product for the upscale couple that buys fine art objects or big wall portraits is delivery of their wedding pictures in a fine art format. The couple receives ten to twenty 4"x5" black and white prints matted in 8"x10" boards. They are stored inside a deluxe leather-covered black box. The are safe in the box and can be displayed as the customer chooses.

□ **Display easels**

Easels are an interesting way to show pictures without having to drill holes in your walls. Easels emphasize the pictures as art, and come in many sizes and designs – from those designed for 4"x5" prints up to models that can hold 20"x24" prints.

□ **Folios**

Folios are cardboard and vinyl albums that are self-supporting. A typical folio will hold several 4"x5" prints. They are used to display groups of related pictures.

□ **Frames**

Carol Andrews offers her clients a framing service. One popular frame contains three 4"x5" prints. "We display the same three black and white fire art prints side-by-side in two different frames. We call it our museum series," she said. "Yuppie brides hate gold frames but their mothers love them...so we let the customer be the judge."

Andrews offers her framing service as a convenience for her clients. "It saves them time money and the trouble of running around town. All of our pictures should go out framed."

□ **Wallet Photos**

Wallet-sized pictures of the wedding packaged in small albums make great thank you gifts from the couple to the wedding attendants – or from the photographer to the couple and their families. A major advantage of providing these tiny pictures is that every time they are shown, they become sales pre-

"Easels are an interesting way to show pictures..."

sentations. Their portability is their primary asset. Few people will carry a five pound album filled with 8"x10" prints to work, church, and the country club because it is much too awkward and cumbersome. But an album of wallet-sized pictures can be carried in a purse and shown any time someone shows interest in the wedding. The wallet albums promote word of mouth advertising and can generate referrals (especially if a business card is included in the back page).

◻ Wall Art

For some brides and many parents, the final product of the bridal portrait session is a large image to hang on a wall. Some photographers emphasize this service. One advantage is that these pictures do not have to be created on Saturdays. Portraits give photographers the opportunity to generate revenue more than one day a week.

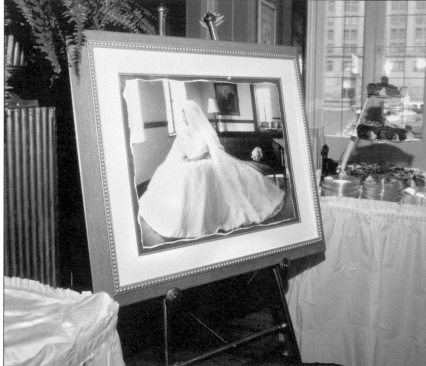

Above: This bridal portrait by Carol Andrews was displayed at the reception near the buffet line. Designed for the bride's or the mother's home, it was used at the reception to impress the guests with the beauty of the bride. It also is a wonderful promotional aid for the studio. Unusual framing and a ragged edge on the print places this picture in the fine art category, which makes its display more easily justified. Photo by David Jones.

Left: This little guest is signing the mat surrounding the couples engagement portrait. Called a signature mat, this product allows guests to express their good wishes to the couple in a way different than the ordinary guest book. The little framed letter below the picture invites guests to sign the mat with the gold ink pen that was attached to the picture stand. Photo by David Arndt.

16
CONCLUSIONS

The repetitive nature of weddings quickly forces photographers into confronting (and answering) the question of why they photograph weddings. Each photographer finds his or her own combination of answers.

Is your reason for shooting weddings compatible with your philosophy of photography? If your beliefs about photography conflict with your reasons for shooting weddings, you will regret that weddings take up time you would rather devote to projects you find more interesting. If you accept wedding assignments only for the money, are you really enhancing the bride and groom's wedding day and investing your best effort into each wedding? If not, you should seek other assignments.

One photographer that contributed pictures for this book accepts wedding assignments with minimum contracts starting at $500. Other photographers start at up to $3,000. The most expensive packages peak at $11,000. Every one of these photographers gives each client their most creative and original work possible. To put it another way, the quality of their work does not vary with their price.

Wedding photography is emerging from the era of formal portraits and group pictures. Couples and families are accepting many styles of photography and novel products. The new freedom is enough to keep photographers with many years experience excited about photographing their next wedding. The creative possibilities are infinite! Wedding couples want your best, most interesting, and creative pictures.

Hopefully, this book has provided you with the information and inspiration needed to explore and master the new styles of wedding photography.

"Each photographer finds his or her own combination of answers."

Appendices

APPENDIX 1: TRAINING

Photography is both easy and difficult to learn. The basics are learned in just a few minutes, while mastery takes a lifetime. Top photographers constantly study books, magazines and attend seminars to pick up new techniques, encounter fresh ideas and study the competition's work.

Beginners in the wedding industry can also make good use of these resources. Many of the photography trade associations hold seminars at local, regional and national meetings. For 75 years, the Professional Photographers Association of America (PPA) has owned and operated photography schools nationwide that teach intensive classes lead by professional photographers. Topics range from basic photography to advanced digital techniques. For full and current information, contact the Professional Photographers of America, (their address, phone and website is listed in Appendix 2). The

National Press Photographers Association also has several important series of programs that are open to members and amateurs.

❑ International Wedding Institute

In 1998, Hasselblad USA Inc. created and hosted a program called the International Wedding Institute. The classes taught the fundamentals of wedding photography, posing, lighting, etiquette, sales strategies and other topics.

Many other manufactures host classes from time to time for their clients and the industry overall. The best way to learn about these training opportunities is to read the trade magazines. The major trade magazines include *Studio Photography & Design, Rangefinder*, and *Storyteller*.

❑ Videos

Some of the nation's leading photographers have produced

101

training videos so they can help others learn their hard-won methods. These photographers also tend to hold seminars worldwide. Many of the video tapes can be borrowed from public libraries through the inter-library loan programs which are free. These same tapes are sold at the larger camera shops or loaned to members by the local trade association chapters.

◻ Apprenticeships

Some photographers hire assistants, knowing that in a few years they will learn enough to start their own business and become a friendly competitor. This informal apprenticeship program is a tradition in the photography industry. Appreticeships benefit both employer and student. It is not necessary to study photography in college in order to be a wedding photographer.

APPENDIX 2:
ADDITIONAL RESOURCES

Many resources are available to assist photographers in solving problems, learning new techniques and delving into photographic history and philosophy. The following sections include websites, associations and books the author found helpful:

☐ Associations

This section lists leading trade associations. Many are not directly related to wedding photography, but all are good resources for solving problems and gathering data.

American Photographic Artisans Guild

212 Monroe, PO Box 699, Port Clinton, OH 43452; PH (419) 732-3290; allynr@dcache.net; 200 members; founded 1966.

Amercian Society of Media Photographers

14 Washington Rd. Ste. 502, Princeton Junction, NJ 08550-1033; PH (609) 799-8300, FAX: (609) 799-2233 <http//:www. asmp.org>; 5,000 members; founded 1944.

American Society of Photographers

P.O. Box 3191, Spartanburg, SC 29304; PH: (803) 582-3115; FAX: (803) 582-3115.

American Society of Picture Professionals

2025 Pennsylvania Ave. NW, Suite 226, Washington DC 20006; PH: (202) 955-5578.

Association of Professional Color Imagers

3000 Picture Place, Jackson MI 49201; PH: (517) 788-8100; FAX: (517) 788-8371; <http:// www.pmai.org/sections/apcl. htm>.

Association of Professional Color Laboratories

3000 Picture Pl., Jackson, MI 49201; PH: (517) 788-8146; FAX: (517) 788-8371; 1,000 members; founded 1968.

Canadian Association of Journalists, Photojournalism Caucus

2 Mullock St., St. Johns, Newfoundland A1C 2R5, Canada; PH: (709) 576-2297.

Canadian Association of Photographers and Illustrators
100 Broadview Ave., Suite 322, Toronto, Ontario M4M 2E8 Canada; PH: (416) 462-3700; <http://www.capic.org>.

Council on Fine Art Photography
c/o Lowell Anson Kenyon, 5613 Johnson Ave., Bethesda, MD 20817; PH: (301) 897-0083; 50 members; founded 1982.

Digital Imaging Marketing Association
3000 Picture Place, Jackson, MI. 49201; PH: (517) 788-8100; FAX: (517) 788-8371; <http://www.pmai.org/sections/dima.htm>.

En Foco
32 E. Kingsbridge Rd., Bronx, NY 10468; PH: (718) 584-7718; FAX: (718) 584-7718 <http://www.f8.com/FP/RESOURCE/ORGS/Enfoco/Enfoco.html>; 525 members; founded 1974.

Friends of Photography
c/o Ansel Adams Center of Photography, 250 4th St., San Francisco, CA 94103, PH: (415) 495-7000; FAX: (415)495-8517; <http://www.photoarts.com/fop />; seefop@aol.com; 5,000 members; founded 1967.

International Association of Panoramic Photographers
P.O. Box 2816, Boca Raton, FL 33427-2816; <http:// www.panphoto.com/welcome.html>

International Center of Photography
1130 5th Ave., New York, NY 10128; PH: (212) 860-1777; FAX: (212)360-6490; <http://www.icp. org>; 6,800, members; founded 1974

International Society of Fine Art Photographers
P.O. Box 440735, Miami, FL 33144; founded 1996.

International Wedding Photojournalists
c/o The Gallery, Attn: John Unrue, 120 East Comstock Avenue, Winter Park Florida 32789; PH: (407) 629-5292; <http://www. unruephoto.com>.

Maritime Professional Photographers Association
<http://www.mppaphoto.com>; founded 1933.

National Association of Freelance Photographers
P.O. Box 970422, Ypsilanti, MI 48197; <http://members.aol.com/thenafp/index.htm>.

National Freelance Photographers Associations
Box 406, Solebury, PA. 18963, 24,000 members founded 1962

National Press Photographers Association
3200 Croasdaile Dr., Ste 306, Durham, NC 27705; PH: (919)383-7246; FAX: (919) 383-7261; 11,500 members; founded 1946.

Photo Marketing Association
3000 Picture Place, Jackson MI. 49201; PH: (517) 788-8100; FAX: (517) 788-8371; <http://www.pmai.org>; 17,000 members.

Pictorial Photographers of America
c/o Henry D. Mavis, 229 W. 12th St., New York, NY 10014-1833;

PH: (212) 242-1117; 85 members; founded 1916.

Professional Photographers of America

57 Forsyth St. NW, Ste. 1600, Atlanta, GA 30303; PH: (404) 522-8600; (800)742-7468; FAX (404) 614-6400; <http://www.ppa-world.org>; 14,000 members; founded 1880.

Professional Women Photographers

c/o Photographics Unlimited, 17W. 17th St., No. 14, New York, NY 10011; PH: (212) 726-8292; 200 members; founded 1975.

Royal Photographic Society

The Octagon, Millsom Street, Bath BA1 1DN, England; PH: +44 (0) 1225 462841; FAX: +44 (0) 1225 448688; <http://www.rps.org>; barry@rps.org; founded 1853.

Wedding and Portrait Photographers International

1312 Lincoln Blvd., P.O. Box 22033, Santa Monica, CA 90406; PH: (310) 451-0090, (310) 395-9058; <http://www.wppi-online.com>; 4,000 members; founded 1973.

◻ Recommended Reading
Business

American Society of Media Photographers. *Professional Business Practices In Photography*. New York. Allworth Press, 1997.

Arndt, David. *Make Money With Your Camera*. Buffalo, New York. Amherst Media, 1999.

Casewit, Curtis W. *Freelance Photography, Advice from the Pros*. New York. Macmillian, 1979.

Heron, Michael and McTavish, David. *Pricing Photography: The Complete Guide To Assignment & Stock Pricing*. New York. Alworth Press.

Hollenbeck, Cliff. *Big Bucks Selling Your Photography*. Buffalo, New York. Amherst Media, 1992.

Documentary Photography

Rothstein, Arthur. *Documentary Photography*. Boston. Massachusetts. Focal Press. 1986.

Fashion

Belson, Al. *Fashion Photography Techniques*. New York. Amphoto, 1970.

Food

Carafoli, John F. *Food Photography and Styling*. New York. Amphoto, 1992.

Law

Chernoff, George and Sarbin, Hershel. *Photography and the Law*. New York. Amphoto, 1977.

Photojournalism

Benson, Harry. *Harry Benson On Photojournalism*. New York. Harmony Books, 1982.

Bilker, Harvey L. *Photojournalism: A Freelancers Guide*. Chicago. Contemporary Books Inc., 1981.

Hagaman, Dianne. *How I Learned Not To Be A Photojournalist*. Lexington, KY. The University Press of Kentucky, 1996.

Hoy, Frank P. *Photojournalism - The Visual Approach*. Englewood Cliffs, New Jersey. Prentice Hall, 1986.

Kobre, Kenneth. *PHOTOJOUR-NALISM: The Professionals' Approach*. Sommerville, MA. Curtin & London Inc., 1980.

Portraiture

Boursier, Helen T. *Black and White Portrait Photography*. Buffalo, N. Y. Amherst Media Inc. 1998.

Professional Portrait Techniques. Rochester, New York. Eastman Kodak Company, 1980.

Photographic Techniques

Coe, Brian, et al. *Techniques of the World's Great Photographers*. Secaucus, N.J. Chartwell Books, 1981.

Freeman, John. *How To Take Great Photographs:A Practical Photography Course*. New York. Smithmark Publishers, 1995.

Freeman, Michael. *Achieving Photographic Style*. New York. Amphoto, 1984

London, Barbara and Upton, John. *Photography, Sixth Edition*. New York. Longman. 1998.

Filters & Lens Attachments. Rochester New York. Eastman Kodak, 1980.

Visualization

Doeffinger, Derrick. *The Art of Seeing, A Creative Approach to Photography*. Kodak Workshop Series. Rochester, New York. Kodak Books,1997.

Grill, Tom and Scanlon, Mark. *Photographic Composition*. New York. Amphoto,1983.

O'Brien, Michael and Sibley, Norman. *The Photographic Eye: Learning to See With A Camera*. Worcester, Massachusetts. David Publications Inc. 1988.

Patterson, Freeman. *Photography & The Art Of Seeing*. Toronto, Canada. Van Nostrand Reinhold, 1979.

Wedding Photography

Box, Barbara. *Storytelling Wedding Photography*. Buffalo, New York. Amherst Media, 2000.

Box, Douglas Allen. *Professional Secrets of Wedding Photography*. Buffalo, New York. Amherst Media, 2000.

Ferro, Rick. *Wedding Photography: Techniques for Lighting and Posing*. Buffalo, New York. Amherst Media, 1999.

Heffner, Joel. *Amphoto Guide to Wedding Photography*. New York. Amphoto, 1981.

Hurth, Robert and Sheila. *Wedding Photographer's Handbook*. Buffalo, New York. Amherst Media, 1996.

Lewis, Greg. *Wedding Photography For Today*. New York. Amphoto, 1980.

Marcus, Andy. *Wedding Photojournalism*. Buffalo, New York.Amherst Media, 1999.

Rice, P., Rice, B. and Hill, T. *Infrared Wedding Photography*. Buffalo, New York. Amherst Media, 2000.

Schaub, George. *Professional Techniques for the Wedding Photographer*. New York. Amphoto, 1985.

INDEX

How to Operate a Successful Photo Portrait Studio

John Giolas

Combines photographic techniques with practical business information to create a complete guide book for anyone interested in developing a portrait photography business (or improving an existing business). $29.95 list, 8½x11, 120p, 120 photos, index, order no. 1579.

Fashion Model Photography

Billy Pegram

For the photographer interested in shooting commercial model assignments, or working with models to create portfolios. Includes techniques for dramatic composition, posing, selection of clothing, and more! $29.95 list, 8½x11, 120p, 58 photos, index, order no. 1640.

Computer Photography Handbook

Rob Sheppard

Learn to make the most of your photographs using computer technology! From creating images with digital cameras, to scanning prints and negatives, to manipulating images, you'll learn all the basics of digital imaging. $29.95 list, 8½x11, 128p, 150+ photos, index, order no. 1560.

Achieving the Ultimate Image

Ernst Wildi

Ernst Wildi teaches the techniques required to take world class, technically flawless photos. Features: exposure, metering, the Zone System, composition, evaluating an image, and more! $29.95 list, 8½x11, 128p, 120 b&w and color photos, index, order no. 1628.

Black & White Portrait Photography

Helen Boursier

Make money with b&w portrait photography. Learn from top b&w shooters! Studio and location techniques, with tips on preparing your subjects, selecting settings and wardrobe, lab techniques, and more! $29.95 list, 8½x11, 128p, 130+ photos, index, order no. 1626

Stock Photography

Ulrike Welsh

This book provides an inside look at the business of stock photography. Explore photographic techniques and business methods that will lead to success shooting stock photos — creating both excellent images and business opportunities. $29.95 list, 8½x11, 120p, 58 photos, index, order no. 1634.

Profitable Portrait Photography

Roger Berg

A step-by-step guide to making money in portrait photography. Combines information on portrait photography with detailed business plans to form a comprehensive manual for starting or improving your business. $29.95 list, 8½x11, 104p, 100 photos, index, order no. 1570

Professional Secrets for Photographing Children

Douglas Allen Box

Covers every aspect of photographing children on location and in the studio. Prepare children and parents for the shoot, select the right clothes capture a child's personality, and shoot story book themes. $29.95 list, 8½x11, 128p, 74 photos, index, order no. 1635.

Handcoloring Photographs Step-by-Step

Sandra Laird & Carey Chambers

Learn to handcolor photographs step-by-step with the new standard in handcoloring reference books. Covers a variety of coloring media and techniques with plenty of colorful photographic examples. $29.95 list, 8½x11, 112p, 100+ color and b&w photos, order no. 1543.

Special Effects Photography Handbook

Elinor Stecker-Orel

Create magic on film with special effects! Little or no additional equipment required, use things you probably have around the house. Step-by-step instructions guide you through each effect. $29.95 list, 8½x11, 112p, 80+ color and b&w photos, index, glossary, order no. 1614.

Family Portrait Photography

Helen Boursier

Learn from professionals how to operate a successful portrait studio. Includes: marketing family portraits, advertising, working with clients, posing, lighting, and selection of equipment. Includes images from a variety of top portrait shooters. $29.95 list, 8½x11, 120p, 123 photos, index, order no. 1629.

The Art of Infrared Photography, *4th Edition*

Joe Paduano

A practical guide to the art of infrared photography. Tells what to expect and how to control results. Includes: anticipating effects, color infrared, digital infrared, using filters, focusing, developing, printing, handcoloring, toning, and more! $29.95 list, 8½x11, 112p, order no. 1052

Other Books from
Amherst Media, Inc.

Wedding Photographer's Handbook

Robert and Sheila Hurth

A complete step-by-step guide to succeeding in the world of wedding photography. Packed with shooting tips, equipment lists, must-get photo lists, business strategies, and much more! $24.95 list, 8½x11, 176p, index, b&w and color photos, diagrams, order no. 1485.

Wedding Photography:
Creative Techniques for Lighting and Posing

Rick Ferro

Creative techniques for lighting and posing wedding portraits that will set your work apart from the competition. Covers every phase of wedding photography. $29.95 list, 8½x11, 128p, b&w and color photos, index, order no. 1649.

Lighting for People Photography, 2nd ed.

Stephen Crain

The up-to-date guide to lighting. Includes: set-ups, equipment information, strobe and natural lighting, and much more! Features diagrams, illustrations, and exercises for practicing the techniques discussed in each chapter. $29.95 list, 8½x11, 120p, b&w and color photos, glossary, index, order no. 1296.

Professional Secrets of Advertising Photography

Paul Markow

No-nonsense information for those interested in the business of advertising photography. Includes: how to catch the attention of art directors, make the best bid, and produce the high-quality images your clients demand. $29.95 list, 8½x11, 128p, 80 photos, index, order no. 1638.

Big Bucks Selling Your Photography

Cliff Hollenbeck

A complete photo business package. Includes secrets for starting up, getting paid the right price, and creating successful portfolios! Features setting financial, marketing and creative goals. Organize your business planning, bookkeeping, and taxes. $15.95 list, 6x9, 336p, order no. 1177.

Lighting Techniques for Photographers

Norm Kerr

This book teaches you to predict the effects of light in the final image. It covers the interplay of light qualities, as well as color compensation and manipulation of light and shadow. $29.95 list, 8½x11, 120p, 150+ color and b&w photos, index, order no. 1564.

Outdoor and Location Portrait Photography

Jeff Smith

Learn how to work with natural light, select locations, and make clients look their best. Step-by-step discussions and helpful illustrations teach you the techniques you need to shoot outdoor portraits like a pro! $29.95 list, 8½x11, 128p, b&w and color photos, index, order no. 1632.

Infrared Photography Handbook

Laurie White

Covers black and white infrared photography: focus, lenses, film loading, film speed rating, batch testing, paper stocks, and filters. Black & white photos illustrate how IR film reacts. $29.95 list, 8½x11, 104p, 50 b&w photos, charts & diagrams, order no. 1419.

Freelance Photographer's Handbook

Cliff & Nancy Hollenbeck

Whether you want to be a freelance photographer or are looking for tips to improve your current freelance business, this volume is packed with ideas for creating and maintaining a successful freelance business. $29.95 list, 8½x11, 107p, 100 b&w and color photos, index, glossary, order no. 1633.

How to Shoot and Sell Sports Photography

David Arndt

A step-by-step guide for amateur photographers, photojournalism students and journalists seeking to develop the skills and knowledge necessary for success in the demanding field of sports photography. $29.95 list, 8½x11, 120p, 111 photos, index, order no. 1631.

The Art of Portrait Photography

Michael Grecco

Michael Grecco reveals the secrets behind his dramatic portraits which have appeared in magazines such as *Rolling Stone* and *Entertainment Weekly*. Includes: lighting, posing, creative development, and more! $29.95 list, 8½x11, 128p, order no. 1651.

Essential Skills for Nature Photography

Cub Kahn

Learn all the skills you need to capture landscapes, animals, flowers and the entire natural world on film. Includes: selecting equipment, choosing locations, evaluating compositions, filters, and much more! $29.95 list, 8½x11, 128p, order no. 1652.

Photographer's Guide to Polaroid Transfer

Christopher Grey

Step-by-step instructions make it easy to master Polaroid transfer and emulsion lift-off techniques and add new dimensions to your photographic imaging. Fully illustrated every step of the way to ensure good results the very first time! $29.95 list, 8½x11, 128p, order no. 1653.

Black & White Landscape Photography

John Collett and David Collett

Master the art of b&w landscape photography. Includes: selecting equipment (cameras, lenses, filters, etc.) for landscape photography, shooting in the field, using the Zone System, and printing your images for professional results. $29.95 list, 8½x11, 128p, order no. 1654.

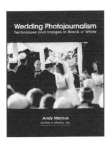

Wedding Photojournalism

Andy Marcus

Learn the art of creating dramatic unposed wedding portraits. Working through the wedding from start to finish you'll learn where to be, what to look for and how to capture it on film. A hot technique for contemporary wedding albums! $29.95 list, 8½x11, 128p, order no. 1656.

Studio Portrait Photography of Children and Babies

Marilyn Sholin

Learn to work with the youngest portrait clients to create images that will be treasured for years to come. Includes tips for working with kids at every developmental stage, from infant to pre-schooler. Features: lighting, posing and much more! $29.95 list, 8½x11, 128p, order no. 1657.

Professional Secrets of Wedding Photography

Douglas Allen Box

Over fifty top-quality portraits are individually analyzed to teach you the art of professional wedding portraiture. Lighting diagrams, posing information and technical specs are included for every image. $29.95 list, 8½x11, 128p, order no. 1658.

Photographer's Guide to Shooting Model & Actor Portfolios

CJ Elfont, Edna Elfont and Alan Lowy

Learn to create outstanding images for actors and models looking for work in fashion, theater, television, or the big screen. Includes the business, photographic and professional information you need to succeed! $29.95 list, 8½x11, 128p, order no. 1659.

Photo Retouching with Adobe® Photoshop®

Gwen Lute

Designed for photographers, this manual teaches every phase of the process, from scanning to final output. Learn to restore damaged photos, correct imperfections, create realistic composite images and correct for dazzling color. $29.95 list, 8½x11, 120p, order no. 1660.

Creative Lighting Techniques for Studio Photographers

Dave Montizambert

Master studio lighting and gain complete creative control over your images. Whether you are shooting portraits, cars, table-top or any other subject, Dave Montizambert teaches you the skills you need to confidently create with light. $29.95 list, 8½x11, 120p, order no. 1666.

Storytelling Wedding Photography

Barbara Box

Barbara and her husband shoot as a team at weddings. Here, she shows you how to create outstanding candids (which are her specialty), and combine them with formal portraits (her husband's specialty) to create a unique wedding album. $29.95 list, 8½x11, 128p, order no. 1667.

Fine Art Children's Photography

Doris Carol Doyle and Ian Doyle

Learn to create fine art portraits of children in black & white. Included is information on: posing, lighting for studio portraits, shooting on location, clothing selection, working with kids and parents, and much more! $29.95 list, 8½x11, 128p, order no. 1668.

Infrared Portrait Photography

Richard Beitzel

Discover the unique beauty of infrared portraits, and learn to create them yourself. Included is information on: shooting with infrared, selecting subjects and settings, filtration, lighting, and much more! $29.95 list, 8½x11, 128p, order no. 1669.

Photographing Children in Black & White

Helen T. Boursier

Learn the techniques professionals use to capture classic portraits of children (of all ages) in black & white. Discover posing, shooting, lighting and marketing techniques for black & white portraiture in the studio or on location. $29.95 list, 8½x11, 128p, order no. 1676.

Marketing and Selling Black & White Portrait Photography

Helen T. Boursier

A complete manual for adding b&w portraits to the products you offer clients (or offering exclusively b&w photography). Learn how to attract clients and deliver the portraits that will keep them coming back. $29.95 list, 8½x11, 128p, order no. 1677.

Infrared Wedding Photography

Patrick Rice, Barbara Rice & Travis Hill

Step-by-step techniques for adding the dreamy look of black & white infrared to your wedding portraiture. Capture the fantasy of the wedding with unique ethereal portraits your clients will love! $29.95 list, 8½x11, 128p, order no. 1681.

Composition Techniques from a Master Photographer

Ernst Wildi

In photography, composition can make the difference between dull and dazzling. Master photographer Ernst Wildi teaches you his techniques for evaluating subjects and composing powerful images. $29.95 list, 8½x11, 128p, order no. 1685.

Dramatic Black & White Photography:
Shooting and Darkroom Techniques

J.D. Hayward

Create dramatic fine-art images and portraits with the master b&w techniques in this book. From outstanding lighting techniques to top-notch, creative darkroom work, this book takes b&w to the next level! $29.95 list, 8½x11, 128p, order no. 1687.

Photographing Your Artwork

Russell Hart

A step-by-step guide for taking high-quality slides of artwork for submission to galleries, magazines, grant committees, etc. Learn the best photographic techniques to make your artwork (be it 2D or 3D) look its very best! $29.95 list, 8½x11, 128p, order no. 1688.

Studio Portrait Photography in Black & White

David Derex

From concept to presentation, you'll learn how to select clothes, create beautiful lighting, prop and pose top-quality black & white portraits in the studio. $29.95 list, 8½x11, 128p, order no. 1689.